PROFESSIONAL DIGITAL TECHNIQUES FOR

NUDE & GLAMOUR PHOTOGRAPHY

Bill Lemon

AMHERST MEDIA, INC. ■ BUFFALO, NY

ACKNOWLEDGMENTS

There are a number of people I'd like to thank for their encouragement to produce my third book. To name just a few:

- my daughter Cindy; my daughter Leslie and her husband Tim; and my four grandchildren, Logan, Sean, Andersen, and Kayla
- the models who appear in this book (Liz, Natalie, Betcee May, Sarah, Dale, and Missy, to name a few)
- Brian Ratty at Media-West
- photographers Art Ketchum, Ken Marcus, Ray Sopczuk, and my friend and assistant, Spencer Calquhoun, for all of their help over the years
- Erik Scheller, Dutch Myers, Lynn Clary, Ann Harris, and others assisting locally
- Barbara, Michelle, Johanne, and Craig at Amherst Media for their help in putting words to these images

Published by:
Amherst Media, Inc.
P.O. Box 586
Buffalo, N.Y. 14226
Fax: 716-874-4508
www.AmherstMedia.com

Publisher: Craig Alesse
Senior Editor/Production Manager: Michelle Perkins
Assistant Editor: Barbara A. Lynch-Johnt

ISBN: 1-58428-178-2
Library of Congress Card Catalog Number: 2005926594

Printed in Korea.
10 9 8 7 6 5 4 3 2 1

TABLE OF CONTENTS

PREFACE

■ BILL LEMON: A SCULPTOR OF LIGHT

I first met Bill Lemon some fifteen years ago in a workshop I was giving in Nashville, Tennessee. Bill suggested we team up to teach some classes. Recognizing his great personality and realizing his talent in the area of glamour and nude photography, I took him up on his offer. It would prove to be a winning partnership.

Through the years I have come to know Bill, and I have the utmost respect for his talent and creativity in photographing women. Bill has a talent that is far greater than even he realizes. He has the ability to project a feeling when photographing a model, and he creates some spectacular images in the process of seeking and seeing the model's greatest assets. Bill also sees light and uses it to sculpt the image in his mind.

Looking at all accomplished and talented photographers' works, you realize they have one thing in common. That talent is knowing the decisive moment in shooting whatever or whoever the subject may be. Bill has that talent and realizes when he has captured the essence of the person he is photographing. As a result, Bill Lemon will be remembered for his unique eye and imitated for many years to come.

As we go through life, we choose friends that have values and tastes similar to our own. Bill Lemon is definitely a photographic soulmate to me—and a good friend.

In teaching my own workshops, I have literally met thousands of photographers over the years. Bill is unique among them, with a vibrant personality that touches everyone he meets. I know I am a better photographer for having met and worked with Bill Lemon.

—Art Ketchum

■ LEMON'S CLASSICAL APPROACH

I first met Bill Lemon a number of years ago when he attended a seminar I was conducting on glamour photography. He was eager to refine his techniques of working with models and mastering lighting. It turned out that we had worked with many of the same models and had shot in many of the same locations.

As a result of his books, I've become familiar with Bill's work over the years, and I appreciate his artistic attention to detail. His classical approach to black & white nudes is a refreshing change of pace in this day and age of hardcore imagery.

—Ken Marcus

INTRODUCTION

I began to experiment with my first digital camera, a point & shoot, fixed-lens Canon PowerShot G1, in April of 2003. I was impressed with the quality of the images and the savings that shooting digitally offered. Since then, I haven't looked back.

While much remains the same when shooting digitally, some aspects of shooting have changed. Dead-on exposure is more critical than ever before. An LCD screen allows you to know immediately whether a picture is a keeper before you even leave the scene. Image-editing is something that every photographer can master to gain unprecedented control over their image making. Shooting digitally, you can more confidently take risks and achieve your artistic goals.

This book will help you on your photographic journey. Whether your primary interest is model photography, fine-art nudes, or female portraiture, you'll uncover the professional tips that will allow you to create dramatic, softly feminine, and incredibly flattering portraits of women. You'll find over one hundred images with accompanying text that breaks down the technical and artistic considerations of capturing the female form in its most glorious form. You'll learn how to create the appearance of longer and slimmer legs, how to whittle a waistline, and curve to the hips, and make breasts look their best. You'll learn how to use artificial lighting techniques for stunning portraits made indoors or outdoors and will get advice for using sunlight to create soft, natural effects. You'll learn the importance of choosing an effective setting and composition, and how to select and work with clothing and props.

1. GLAMOUR

Glamour images can be created with any client, regardless of their level of comfort in taking nude images. In this section, you'll see that clothed images can be sexy, and that the glamour genre has grown leaps and bounds and now includes more than perfectly coiffed hair and lots of lipstick.

There's a certain appeal for me in pairing the smooth, lovely skin tones and graceful lines of the feminine form with the weathered, rustic appeal of old farm equipment. In image 1, that texture comes from an old flatbed truck that Ashley leaned against. I wanted to create an image of Ashley that had a certain girl-next-door appeal, and I think that feeling comes across nicely in this shot.

While I often crop images in the computer, this image was cropped in-camera to draw the viewer's attention to the model's hair and face. The shot was captured in manual mode with a Nikon D100 and a 28–75mm Tamron lens. Flash fill brightened the shadows on Ashley's face and add catchlights to her eyes.

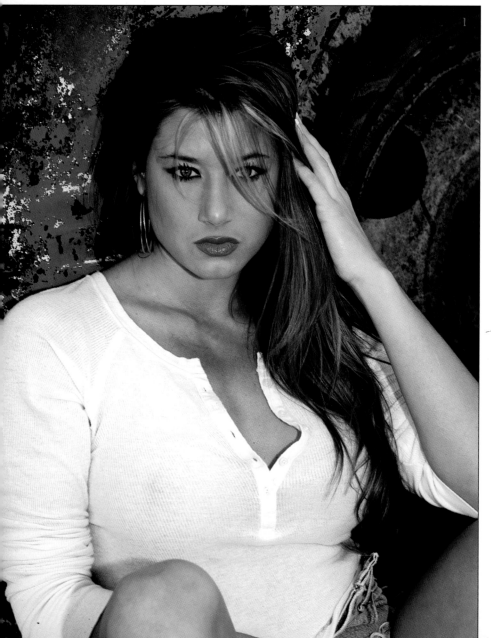

◼ CURVES

There's no denying the appeal of the S-curve throughout the length of the body of the model shown in image 2. Natalie exudes femininity, sex appeal, and a particular playful exuberance in an image that shows off all of her feminine charms.

I asked Natalie to lay on her side, and she refined the pose herself, placing one hand on her face and one on her chest. She put a lot of energy into the image, and there's a feeling of joy in it. I focused on her eyes in taking this image, and her gaze engages the viewer.

Natalie was posed atop a rolling platform covered with a swath of black velveteen fabric that serves as a make-shift bed for the the session.

I shot the image with a Nikon D100 and a 28–75mm Tamron lens. The flash, positioned at camera left, was set at full power.

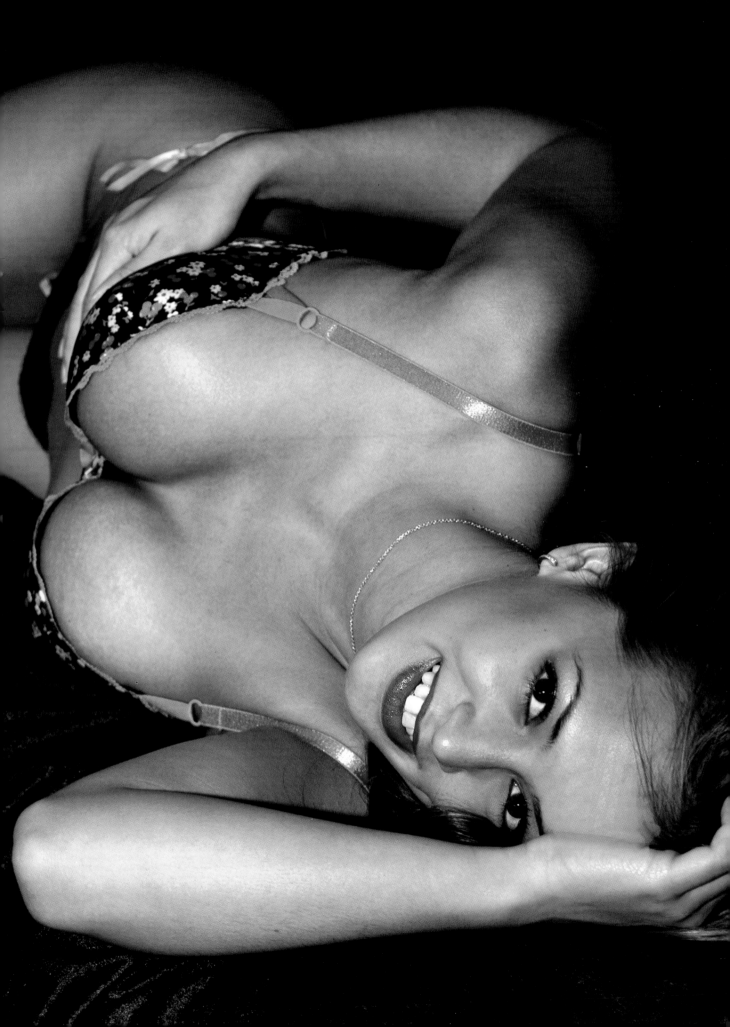

◼ MODELS

I've been in this business for twenty-five years now, and I've photographed countless models. Most are referrals from past clients. Once you've proven yourself as an artist and a respectable professional, your business will grow by leaps and bounds.

With the wide variety of modeling websites available, it's never been easier to find a subject ready for hire who suits the type of image you aspire to create. Check websites like www.onemodelplace.com for leads. Also, many established models now host their own websites. A simple search should yield countless links worth investigating.

Regardless of the type of image you shoot—swimsuit, implied nude, nude, glamour—you'll find that most models now demand payment for each session. With a need to pay models, the cost savings inherent in shooting digital is more important than ever before.

◼ IN THE PINK

Image 3 was created in a Charlotte, North Carolina, hotel room. I created several long shots, then came in close for this image, made with a Nikon D100, a 28–75mm Tamron lens, and an on-camera flash.

I directed Kaylee in creating this pose, and she refined it by placing her hand on her right shoulder. I love the soft, feminine look it imparts, especially in combination with the direct eye contact and sensual mouth. Her clothing selection lends energy to the image and draws attention to her curves.

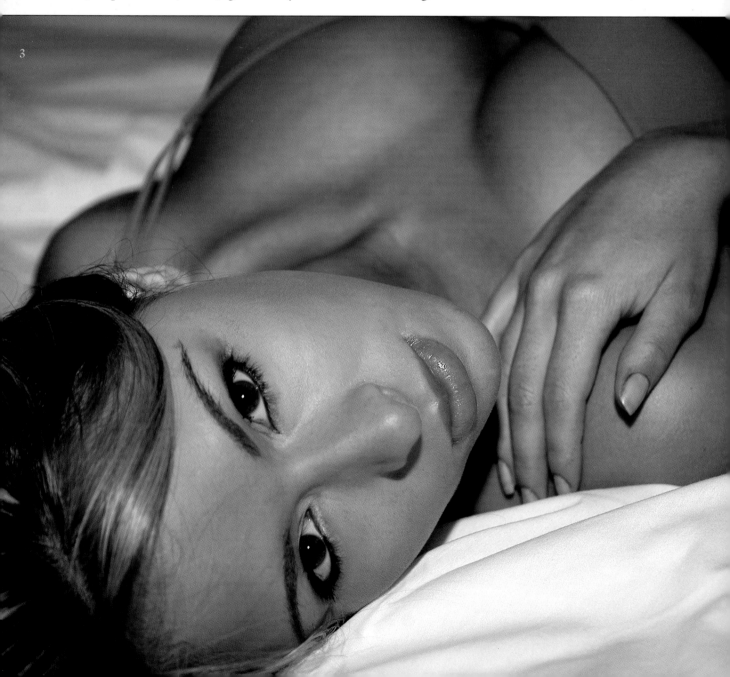

3

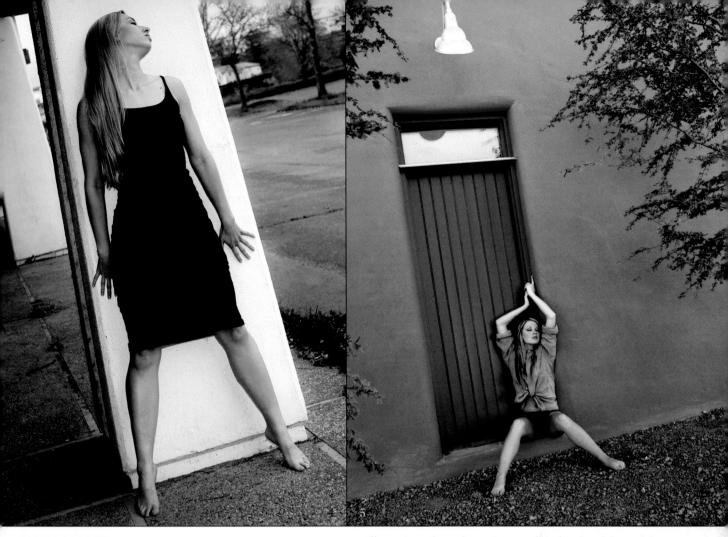

◼ DYNAMIC LINES

Image 4 was made at an old abandoned building near my home. I shot the image at an angle to show the row of pillars behind Kristin, which gives a sense of dimension in the image.

The sheer slip dress Kristin selected for the image provides a somewhat modest glimpse of her body. I darkened the fabric in the pelvic area in Photoshop to conceal a little more.

The session took place on a chilly day, so we shot just twenty frames. This one was shot on a Nikon D100 with a 28–75mm Tamron lens.

◼ A BURST OF COLOR

When scouting for new photogenic locations in Tucson, Arizona, I came across the private residence shown in image 5. Arizona and New Mexico are renowned for the gorgeous architectural color schemes. When I saw this house, I thought, "I need to shoot this front door." However, if you look closely at the image, you'll notice that there is no doorknob—it's a fake door, used only for decoration.

I knocked on the home's *functional* door, hoping to get permission to use the residence as a backdrop for Heidi's session. When I got no answer, I proceeded with the shot and hoped for the best. Midway through the session, the homeowner, a fellow artist, arrived on the scene. He was enthusiastic about the session and invited me to shoot in the backyard as well.

I love the contrast of the vibrant blue door against the orange stucco walls. I would have liked to show more of Heidi's body in the image, but she wanted a conservative shot.

I like the composition in this image. Heidi's off-center placement and the tilted camera created a dynamic feel in the image, while the branches at the left and right of the frame point to the subject and provide additional color.

The image was captured with a Nikon D1X and a 35–70mm Nikon lens.

◼ HAWAIIAN ISLAND

Images 6 and 7 were made during a swimsuit location shoot on the Hawaiian island of Oahu.

Karen wanted to shoot images that were sexy without showing too much. I asked her to remove her swimsuit top, and we created an image that implies complete nudity while evoking a somewhat modest feel.

Karen developed and executed the posing concept. Her arms create a sense of movement in the image and playfully obscure most of her breasts. She raised her left hip, a posing strategy that accentuates her trim waistline and plays up the curve in her hip. The slight tilt of her head and the hair pulled toward the left shoulder also add interest to the image. To me, having the hair piled on one side opens up the model's face.

For image 7, Karen changed swimsuits and put this net top on. I like the texture it adds to the image, and its color complements the oceanic backdrop. The image is tightly cropped but shows enough background to create a sense of place.

Karen's crossed arms direct the viewer's gaze to her face and ensure the modesty that she wanted to achieve in the image. I love the glistening highlights that the summer sun created in her hair.

Both images were made with a Nikon D100 camera fitted with a 28–75mm Tamron lens.

◼ CLASSIC ELEGANCE

Image 8 was shot in Victoria, Texas, during a workshop I was conducting. The setting is the reception area of a dentist's office.

Liz appears several times in this book. I like to photograph her, and we've shot all over the country together.

Liz's lovely hair and classic profile suit the concept of the image nicely. If I had the opportunity to change any aspect of this image, I would have requested that Liz select a black bra and panties, as the darker color would have created better contrast with her skin tones and the furniture.

The lighting setup for the image was simple but effective: I placed a single 4x6-foot softbox 45 degrees to camera left.

This image was taken with a Nikon D100 and 28–75mm Tamron lens.

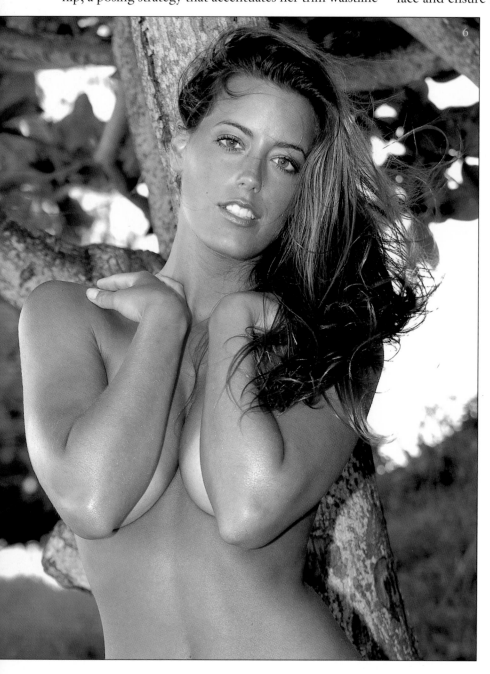

6

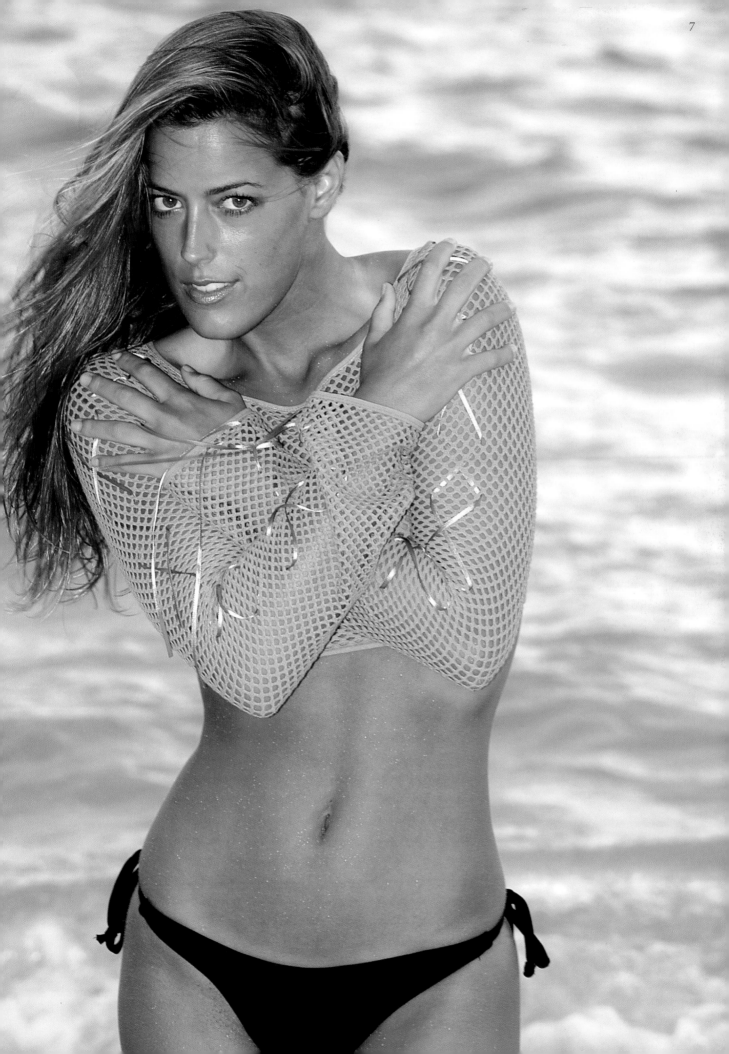

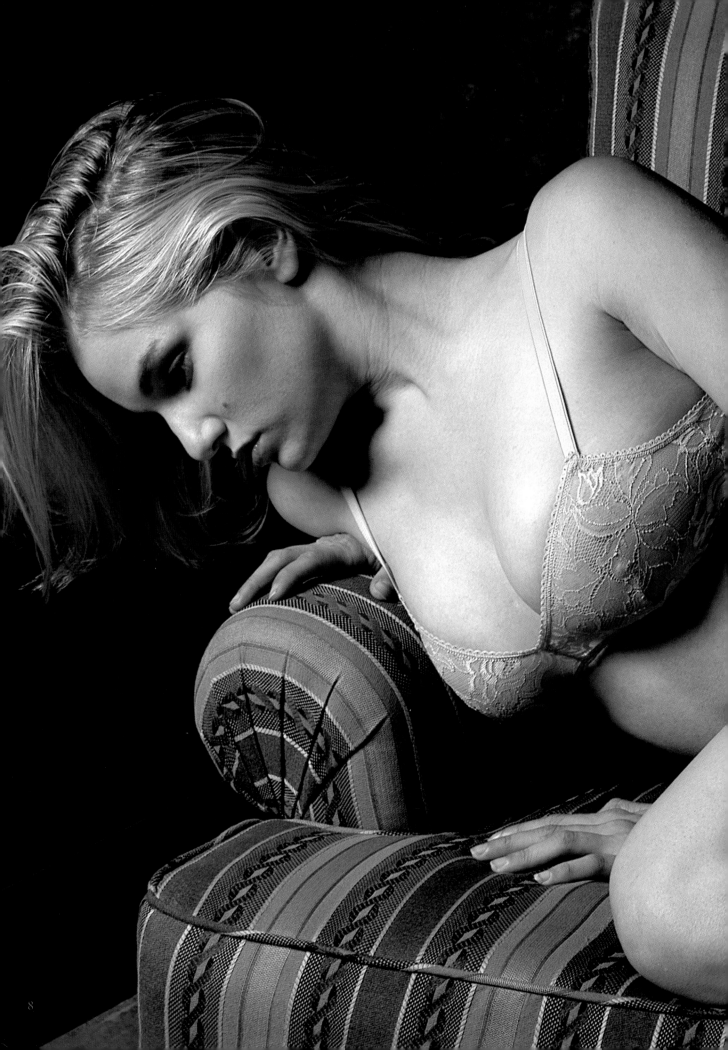

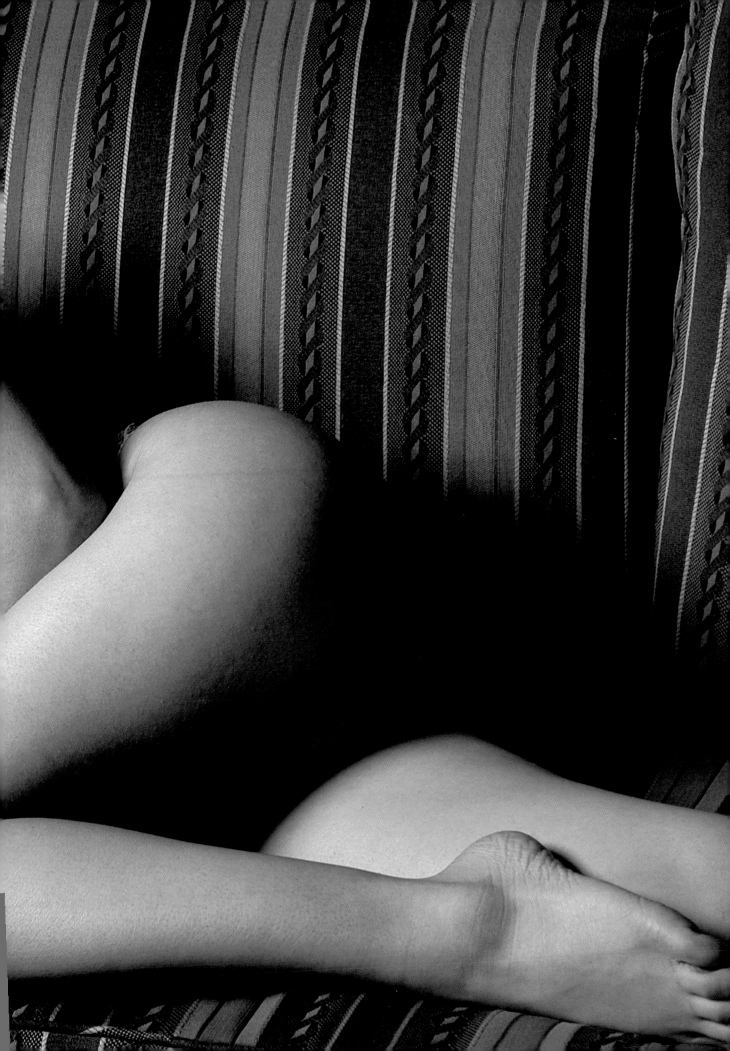

OVEREXPOSURE

Image 9 was shot in an area adjacent to my studio. The model, Stephany, was just fifteen years old when the image was taken. She had heard about my work from another photographer and contacted the studio.

Stephany's mom was initially a bit reluctant to allow her daughter to do the session because she was aware that I photograph nudes. She and I spoke at length on the phone and, once assured of the tasteful, professional nature of my images, she gave her consent for her daughter to be photographed. Her mom was present throughout the shoot.

This image was made with a Nikon D100 with a 28–75mm Tamron lens and flash fill. I purposefully overexposed the image to wash out her skin tones.

I love the shape of Stephany's face and the way that the layers in her hair draw the viewer's attention to her features.

SUN WORSHIP

Image 10 was made in Baton Rouge, Louisiana, as part of a workshop I was conducting.

Renee is shown lounging gracefully in a wicker chair on the porch of a house situated on an old plantation set far back from the main road. The tilt of her head and closed eyes allowed me to capture good light on her face and also creates the impression that we've caught her in a private, reflective moment.

Renee selected the white bathing suit for this image. I like the way that the white chair and clothing and the pale yellow walls combine to create a peaceful mood in the image.

I captured this image with a Nikon D100 with a 28–75mm Tamron lens and flash fill.

VALLEY OF FIRE

I lead a great many workshops in a wide range of locations, and image 11 was made during a workshop held in the Valley of Fire in Nevada. The spot is a natural choice for many outdoor and location photographers, and I especially love the texture and warm coloration the scenery lends to my images.

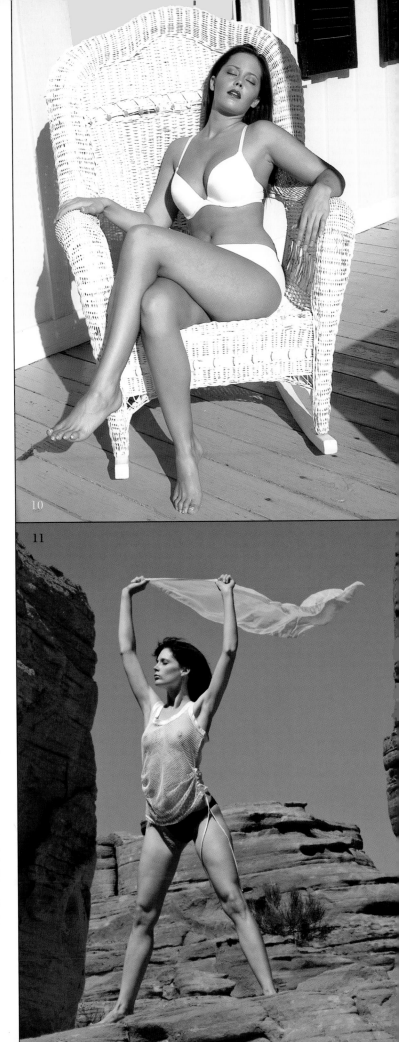

10

11

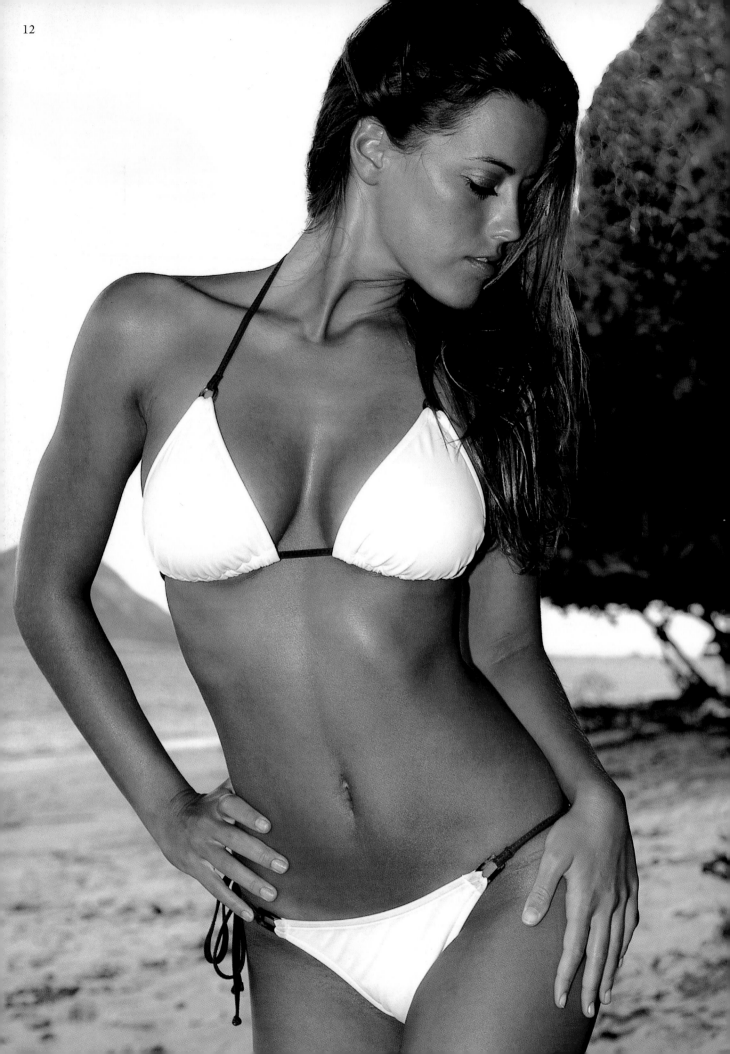

I asked Sarah Kate to raise the white scarf above her head and made the shot. I like the way the rock frames the image and enjoy the strength she exhibited in this pose.

The image was made with a Fuji S2 and a 24–85mm Nikon lens. I used flash fill to boost the light levels in the scene. While the warmth of the coloration of the rock, the deep blue sky, and the greenery add interest to the image, I felt that the original image lacked a little punch. To solve the problem, I brought the image into Photoshop and used the Magic Wand tool and Brightness command to selectively boost the color in the rocks.

■ S-CURVES

The strong S-curve Karen produced in posing for image 12 draws the viewer's gaze from the tilt of her head through her torso, hip, and upper legs, resulting in a lovely composition. Note that I selected an angle of view that placed the horizon line in a pleasing position in the portrait. When composing an image, it is important to ensure that the lines in the image do not distract the viewer from the subject. Instead, we want to be sure that the lines cross the body in a flattering way. Never allow horizon lines to cross the subject's face or neck, for example.

The image was taken with a Nikon D100, a 28–75mm Tamron lens, and flash fill. The highlights on Karen's skin draw attention to her curves and emphasize her shape.

Although I captured this image using the aperture priority mode, I shifted to strictly manual manual mode soon after this session in order to achieve consistency in exposure from one image to the next.

■ CITY CHIC

Ashley wanted to create an image that "didn't show any skin." The torn jeans and open leather jacket in image

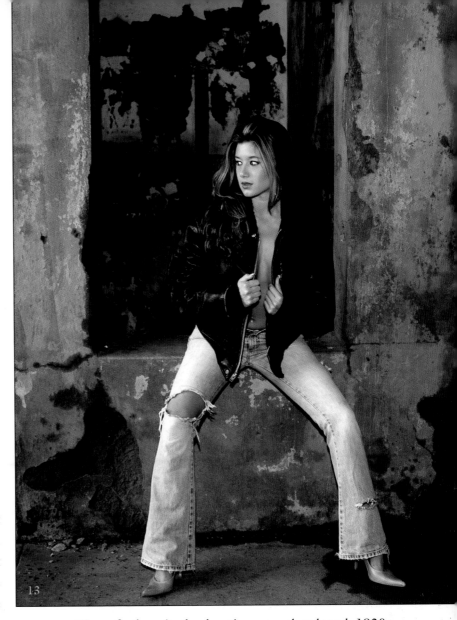

13 perfectly suit the location—an abandoned 1920s concrete bunker located near the San Francisco bay. As you can see, a model doesn't need to be nude to create a sexy image. A lot depends on her attitude when she arrives for her session. If you can ensure her comfort and provide positive feedback, great images will result.

Toning a black & white image can create a different, perhaps more artistic, mood in an image. While attending the Epson Print Academy, I learned to convert digital images from color to black & white and to tone the images in Photoshop. I can convert straight to a sepia tone, or any tone I want, for that matter.

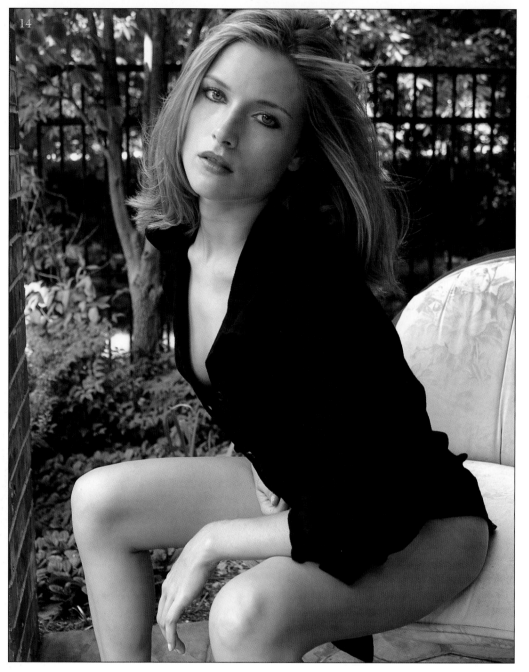

14

very time-consuming. In this case, the varying tones and textures in the foliage would make digitally removing the fence a very difficult task.

For image 15, I positioned Reanna under an overhang to block some of the harsh overhead light, then took a light reading of her face, and set my Nikon 80D flash, on a flash bracket, at f5.6 at $\frac{1}{125}$ second, per the meter reading. A quick check of my LCD screen showed that shooting at full power produced an overexposed image, so I turned the flash down three stops to get this result.

The depth of focus in this image falls off quickly, rendering the foliage in the background more abstractly and thereby eliminates distracting elements in the photograph. Limiting the sharp focus to Reanna's eyes ensures that her beautiful, sensual features are the most prominent element of this beautiful portrait.

◘ DISTRACTING ELEMENTS

Images 14 and 15 were captured in Dallas, Texas, during a one-one-one workshop I recently conducted there.

Reanna came up with the pose for image 14, and I cropped the image in camera to eliminate some of the concrete area around her feet.

I feel the wrought-iron fence behind the model distracts the viewer from her features. Before making a shot, it pays to survey the scene to ensure there are no distracting elements. While many post-capture corrections can be made in Photoshop, the process can be

I did a little bit of post-capture work in Photoshop to retouch Reanna's undereye area, then boosted the color saturation a little to make the tones in the image "pop." I've found that most of the models benefit from a small amount of retouching in the undereye area, and an increase in color saturation typically improves the image as well.

Both images were captured with a Nikon D100 and a 28–75mm Tamron lens.

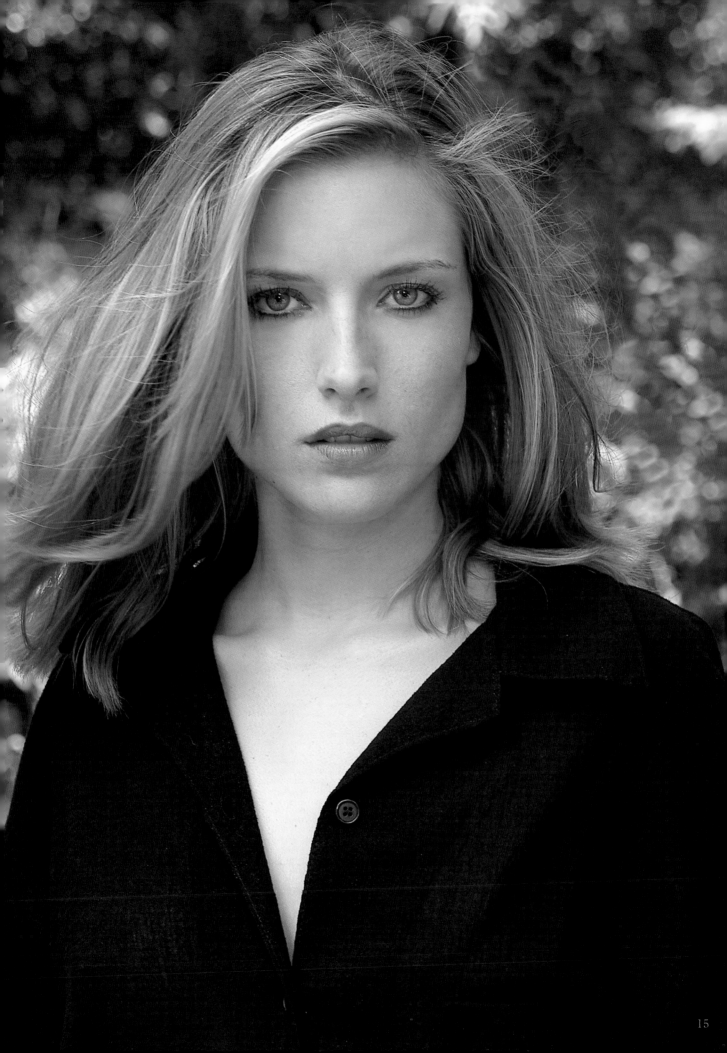

2. WATER

ater can provide a lot of visual interest in nude photography. Whether it takes a central role or seems to "accessorize" a scene, it can create contrast and sparkle. Water can even serve as a sort of camouflage for a model who wants to create an implied nude image.

In image 16, Danielle was positioned at the lower-right third of the image. Because the session was held late in the day, I had an assistant positioned on either side of her with zebra reflectors to bounce warm light back onto her skin. When working with water, it is critical that you expose for the skin tones.

While the natural background is prominent, it does not overwhelm the model. I like the way the rocks and flowers punctuate the image with color, and feel that including the landscape adds to the storytelling quality of the image. Positioned with her hands on the rocks, it appears that Danielle is seeking shelter from the gaze of onlookers who have come onto the scene.

Image 17 was taken during the same session. I converted the original color image to black & white and lightened the dark areas of the wet rock in Photoshop. The backlight in the image creates the necessary separation between Danielle's hair and the background.

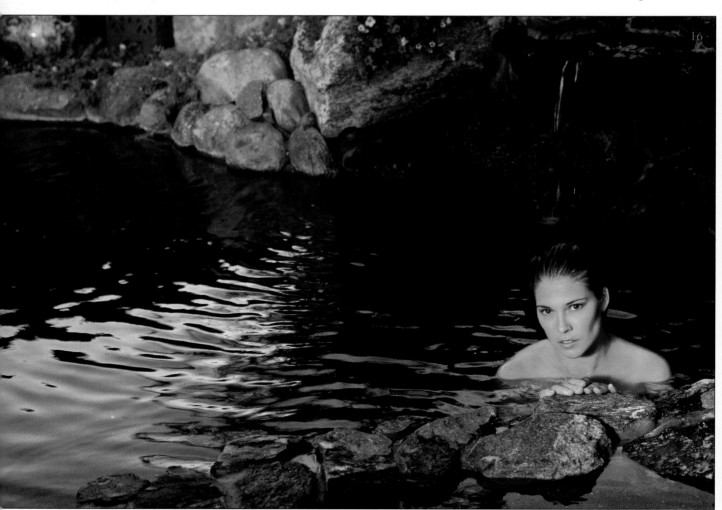

16

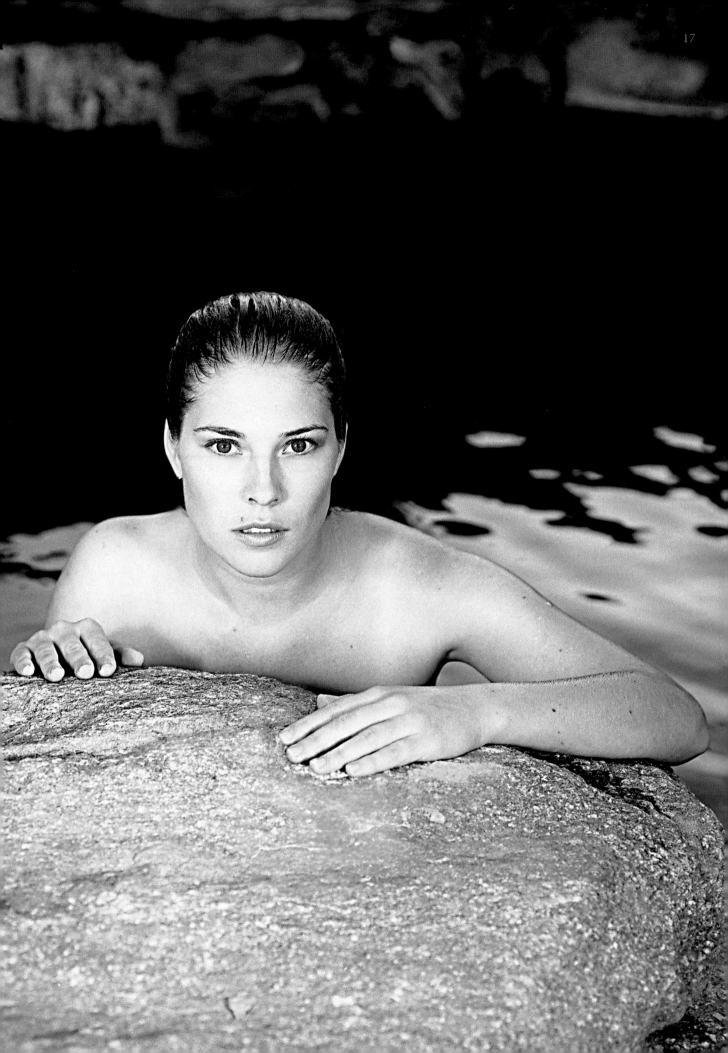

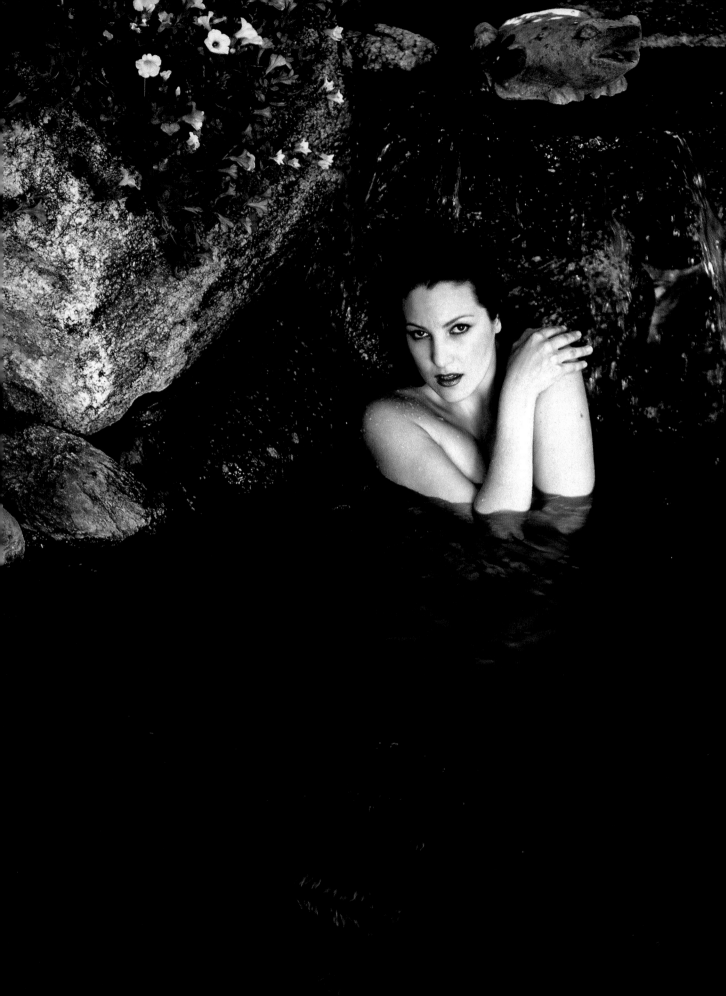

LOCATION, LOCATION

Image 18 was shot in the same location as images 16 and 17 on the previous page spread. The backyard spa is situated behind the picturesque, vibrant orange stucco residence shown in image 5. The location has proven to be a favorite of mine, and I've conducted numerous sessions there. A diverse array of images is the result.

To create this image, I positioned Elizabeth right under the waterfall at the far end of the pool. She didn't want to show too much skin, and while the water conceals two-thirds of her body, she nevertheless exudes a highly sensual energy. The sun was directly behind Elizabeth when the image was made, so we used a 39x39-inch silver reflector to bounce light onto her skin and fill in the shadows.

Note that Elizabeth isn't quite centered in the frame. She's positioned a bit high and slightly right of center in the image. Center placement is commonly considered a somewhat stagnant presentation for the subject of an image.

A LITTLE BIT OF PARADISE

Image 19 was made in Paradise, California at a jewel of a location tucked away at the end of a long, dirt road.

Sarah came up with her own pose for the image. The result is a lovely, classic, and form-flattering position that is beautifully juxtaposed by the rough and jagged texture of the rock.

Note the hint of skin tone that appears in the water at the bottom of the frame.

Because the image was made late in the day, there's a blue cast to the scene. Shot earlier in the day, the same rocks appear much warmer, resulting in an image with a very different feel.

The image was shot with a Nikon D100 and a 70–300mm Nikon lens. While it is shown here in color, I have found that the portrait is equally effective in black & white.

IMAGE PREVIEWS

While the availability of an LCD screen is an obvious advantage to shooting digitally, I do not share the images with the model in the midst of the image-capture process. Though many photographers feel that showing an image during the shoot can increase the model's sense that the session is going well and boost her confidence, I feel that it breaks the rhythm of the shoot. I do share the results of the session with the model—but for me, it makes sense to wait until the end of the shoot.

I do typically rely upon my LCD screen to analyze a shot, though. This ability is just one of the benefits of shooting digitally.

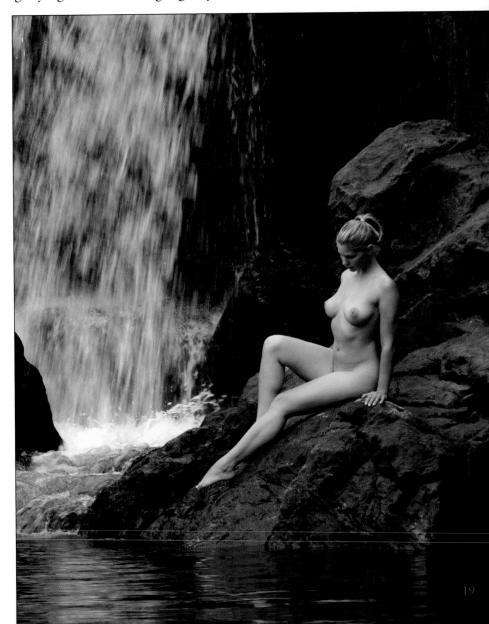

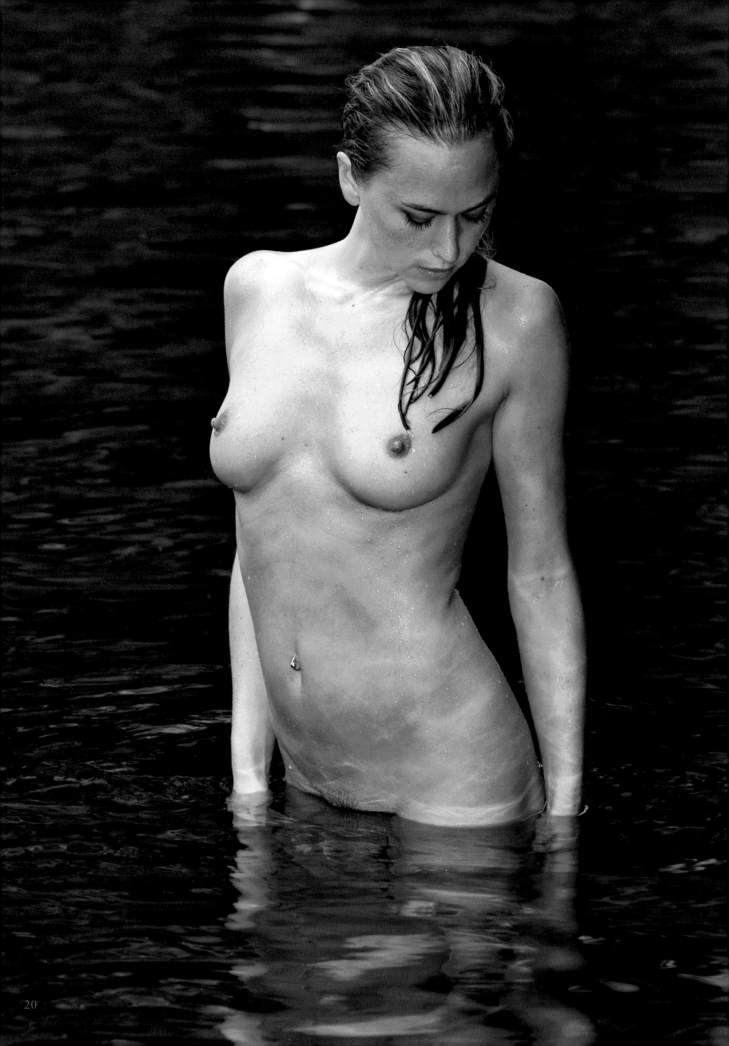

◼ LATE-DAY SUN

In image 20, Justine posed in front of the waterfall that also appears in image 19. She developed the pose herself, and I love the result. I typically try not to crop a model's hands out of the image; if I could shoot this image again, I would have ensured Justine's hands were fully visible.

The image was captured late in the day with a Nikon D100 and a 28–75mm Tamron lens. To warm Justine's skin tones, I taped a Bastard amber gel over the flash. While these gels are available in a wide range of filter strengths on the Internet, the #15 I selected for this image produced the perfect result. I've more recently begun using Sto-fen's Gold Omni, a warming device designed to slip over the flash head, eliminating the hassle of fumbling with tape during the shoot (see www.stofen.com for details). I've been experimenting with a B+W KR3 filter—a warming filter—on camera, but I've not had consistent results. However, all of my other traditional filter effects are now easily achieved in Photoshop.

Image 21 was created in a residential pool. Natalie selected the clothing and orchestrated the pose for the image after I asked her to raise the left side of her dress. I like the eye contact with the camera and the "confrontational" expression on her face.

The image was taken late in the day, and the sun's position produced rim lighting and great highlights in her hair.

In image 22, Natalie is wearing a long, sheer gown that adds texture to the image but leaves little to the imagination. Her raised arms and angled torso provide a beautiful view of her bust and waistline. Her face was turned up toward the sun to ensure that she was well lit. The expression perfectly suits the pose, and her makeup is soft and natural. For the type of work I do, the women wear very little makeup, and they apply it themselves. I'm mostly interested in producing a more natural, girl-next-door type of image. For glamour or beauty portraits, more obvious makeup is usually required.

Both images of Natalie were made with a Nikon D100 and a 28–75mm Tamron lens and flash fill.

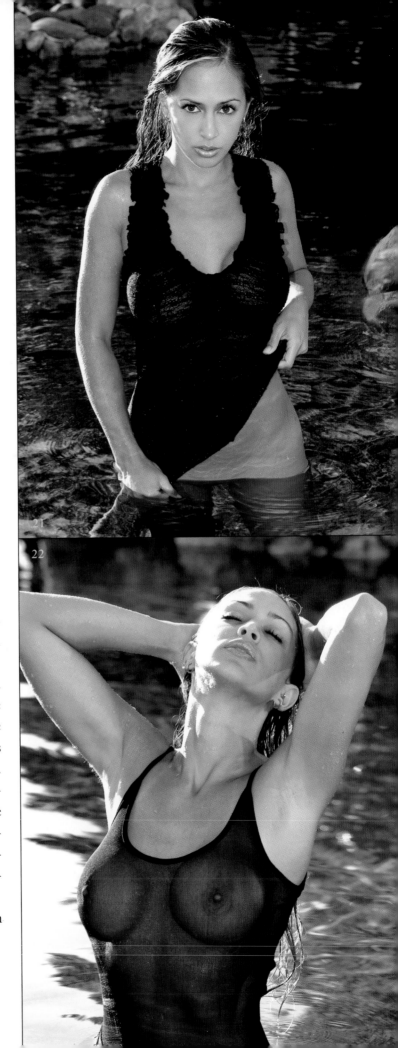

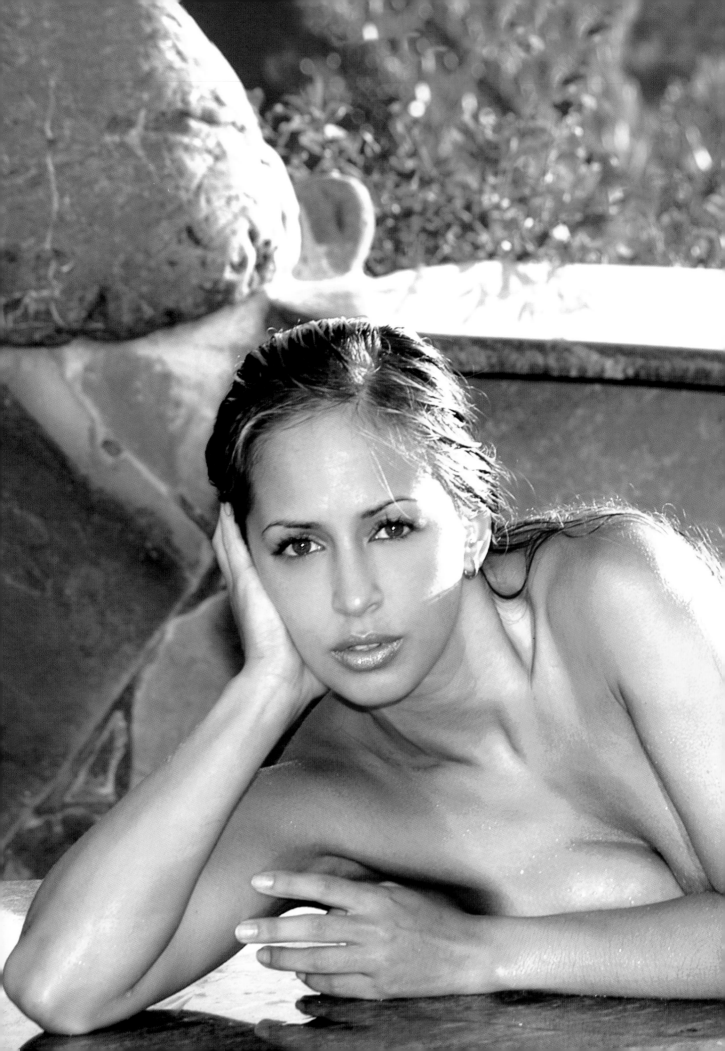

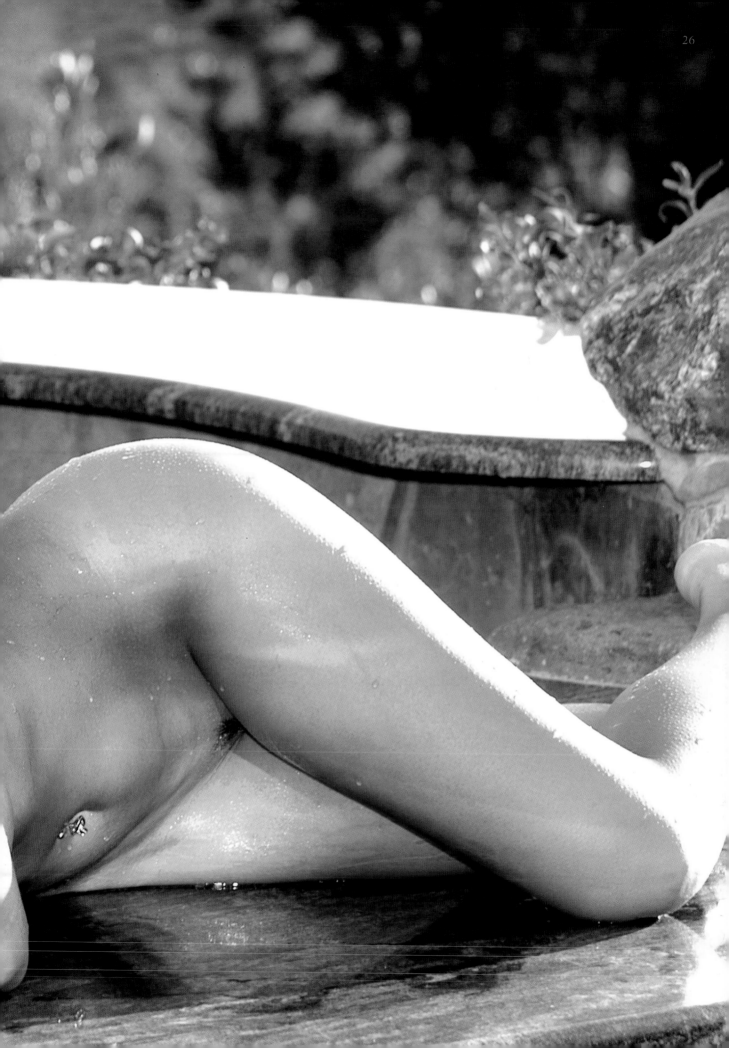

■ MAKING THE PICTURE TALK

Image 27 was captured at the same location shown in the previous waterfall images that appear in the book. Justine's lower half is in shadow, and her torso is brightly lit, an effect that could have been produced by a spotlight but is, in fact, the work of the sun.

Most photographers would have shot this image with a zoom lens to render the subject larger in the frame. I purposefully composed the image to show the top of the waterfall and the greenery. Though Justine is quite small in the frame, her dynamic pose and and the contrast between her body and the surroundings lock the viewer's gaze on her beauty.

The image was made with all natural light and was captured on a Nikon D100 with a 70–300mm Nikon lens.

I've shot from the east to the west coast. I've done a lot of work in New York, Texas, Arizona, Mexico, Louisiana, and Nevada. A lot of my shooting at these locations coincides with my workshops. I'll build a couple of days into my itinerary to take advantage of the various locales and their unique landscapes. As you'll read in the pages that follow, I shoot a lot of images in my home state of California, too. While the majority of my images are shot outdoors and incorporate a natural landscape, I do some sessions in the studio as well.

You've got to work a location for all it is worth. Explore the landscape. Get creative. Shoot from various angles with a variety of lenses and in differing lighting conditions. Open your eyes to new possibilities and step off of the beaten path. Why travel thousands of miles just to make images that look like everybody else's?

When coaching other photographers on shooting outdoor and location images, I always tell them, "make the picture talk."

■ BACKLIGHTING

When you backlight a subject, you've got to add additional light to her face via a reflector or flash fill. For this portrait, flash was used to do the job.

Natalie is a natural when it comes to posing; in image 28, the pose is dynamic and playful. The angle of her hips and thighs conceal some of the pelvic region, and the composition leads the viewer from her face through the curve of her back and to the right edge of the picture. Selecting a wide aperture allowed me to blur the background to ensure that the focus remained right where it should, on Natalie.

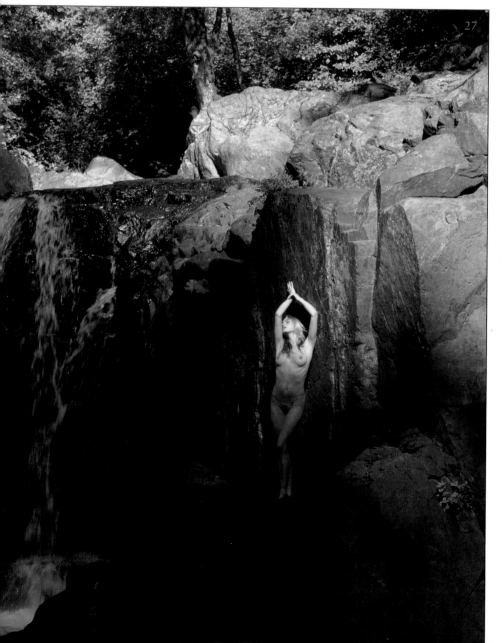

27

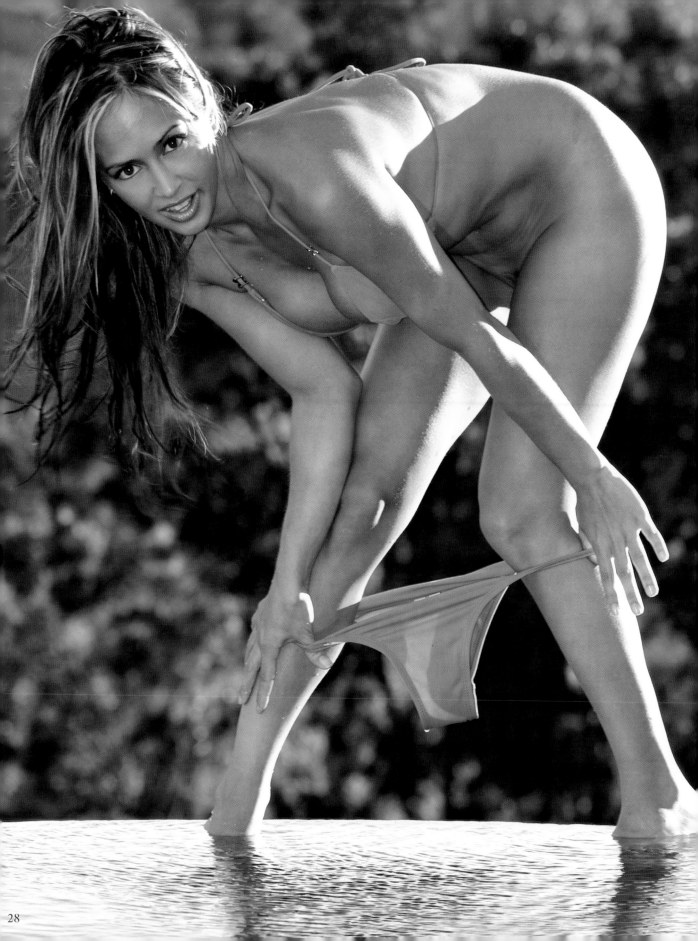

3. LANDSCAPES

When working with a model, we often travel to a variety of landscapes in a single session. A change in locale is one of the easiest ways to vary images taken for a model's portfolio, or just to revel in the multitude of artistic opportunities that a change in the landscape affords.

In image 29, Jenny is standing in the middle of a plowed field. The image seems to exude heat; the ground looks barren, and there is nothing that distracts from the model. Only her lipstick adds color to an otherwise earth-toned image. The image was captured with a Nikon D100 and a 70–300mm Nikon lens.

In image 30, Jenny is positioned facing the sun. At her feet you will notice the remnants of an railroad track now overgrown with weeds. I feel that the lines of the track add to the composition of the image.

The image is full of vibrant color; the greenery is intensely colored, and the rich color of the shirt corresponds nicely to the blue sky in the background. The yellow flowers add still more energy to the image, which was captured with a Nikon D100 and a 28–75mm Tamron lens.

■ ASSISTANCE, PLEASE

When creating nude images on location, an assistant can prove doubly helpful: in addition to positioning equipment, directing light with reflectors, etc., he or she can also help to ensure that your model isn't surprised by a person who unwittingly walks onto the scene of your shoot.

On one occasion, I was photographing a model in an area adjacent to a pheasant club. All of a sudden, a guy with a shotgun and a hunting dog rounded the corner, crossing paths with the model, who was wearing only

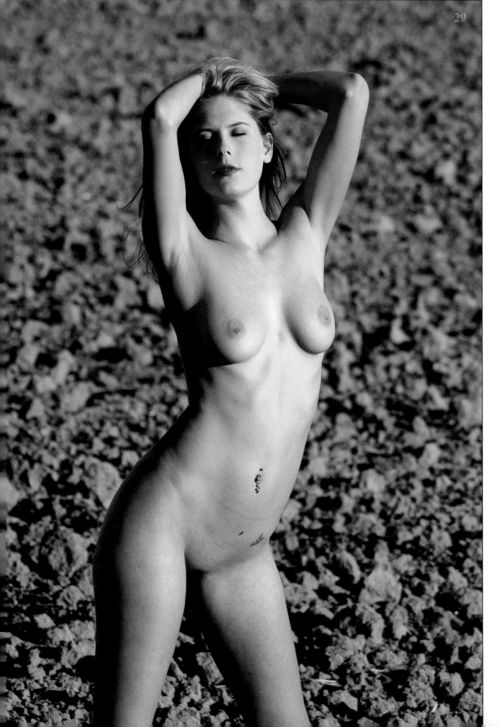

29

a wide-open fishing vest. The hunter told his buddies about the experience, and they didn't believe him. He tracked me down and came to my studio to ask for a copy of one of the images. Since then, I've come to know him quite well.

Many models don't mind such encounters. They're quite comfortable in the nude and aren't particularly self-conscious. When working on location, though, we generally keep a shirt handy so the model can quickly cover up in case of an "emergency."

Image 31 was created on a bridge that crosses the waterfall location shown previously. I asked Justine to walk toward the camera and simply captured the image when her position seemed right. I love the interplay between the natural landscape and the man-made wood and steel bridge and graffiti.

I love the leading lines in the portrait, which seem to reinforce the model's movement toward the viewer. The image was taken late in the day with a Nikon D100 and a 28–75mm Tamron lens and flash fill.

◼ NEVADA

Image 32 was created late in the day with a Nikon D100 with a 70–300mm Nikon lens and a Nikon 80DX flash. To achieve a warmer feel in Liz's skin tones, I placed a Sto-fen Gold Omni diffuser over the flash head. Before digital, photographers used a #81A warming filter when shooting in the shade or under late-afternoon sunlight. The gold diffuser is an easy antidote for such lighting scenarios.

Liz did her own posing and accessorizing for the image, which was made for a modeling website named www.michelle7.com.

Nevada's Valley of Fire is the background for both images 32 and 33.

Though the location is the same, the two photos clearly illustrate the range of expressions that can be achieved in a given spot. While image 32 is more tightly cropped to aggressively feature the model, the background is used to establish mood in image 33.

Note, too, the difference in the tonal qualities of the two images. The photograph below was captured just before noon and exudes a warm glow that surpasses that achieved with the gold diffuser. While Karen's coloration is quite similar to the color of her surroundings, her striking form draws the viewer's eye to her strong and graceful form.

◼ STORYTELLING IMAGES

I create images with dimension, photographs that tell a story. Each model's expression and body language suit

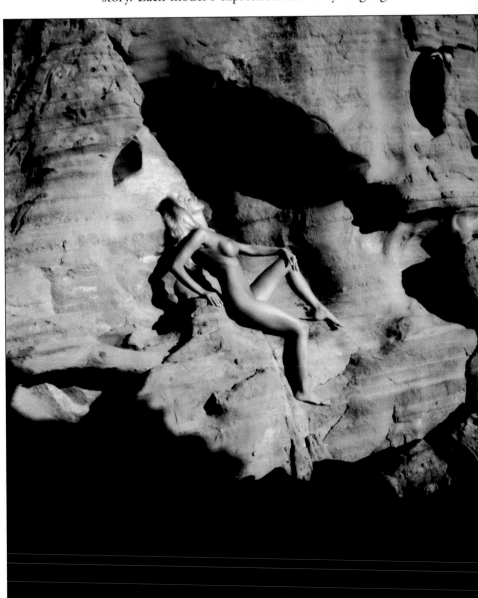

■ DESERT SCENES

In image 40, Liz is shown in a pose that's full of attitude and yet is completely feminine. The image was taken late in the day with a Nikon D100, fitted with a 70–300mm Nikon lens, on a tripod. I used all natural light to get the shot. Light bouncing off of the warm-colored rock intensifies the warm color temperature of the late-day lighting. Also, because Liz is quite fair-skinned, I boosted the color saturation in the image in Adobe Photoshop to add increased warmth in her skin tones.

Liz is wearing a long, gauzy jacket that's been allowed to fall open and off of her shoulders. It belonged to another model whom I photographed several years ago. I fell in love with the garment and plan to one day photograph a model wearing it while emerging from the water. Here, Liz added a personal touch to the outfit with a black belly chain, worn as a sort of makeshift belt around the jacket. The accessories she is wearing are her own.

Image 41 shows Nikki, who served as a model for a photo workshop I conducted at the Valley of Fire, Nevada. The portrait was made with all natural light. I love the way the deep shadows frame the left and bottom edge of the image and direct the viewer's eye toward the model. The foliage helps to add color and a touch of softness to the image. Nikki's pose is well executed, dance-like, and dynamic.

In image 42, Sarah Kate's pose is much stronger and has a more athletic quality than many of the others shown in this book. The low camera angle creates the illusion of a longer body line, and the angles created in her arms and legs add a sense of attitude and artistry to the image.

The position of the sun created a lighting pattern that mimics the effect of a spotlight. Her upper body is in highlight, and her lower body is in shadow. This draws attention to her face and torso, an action that is reinforced by the deeply shadowed foreground, which beautifully frames the subject.

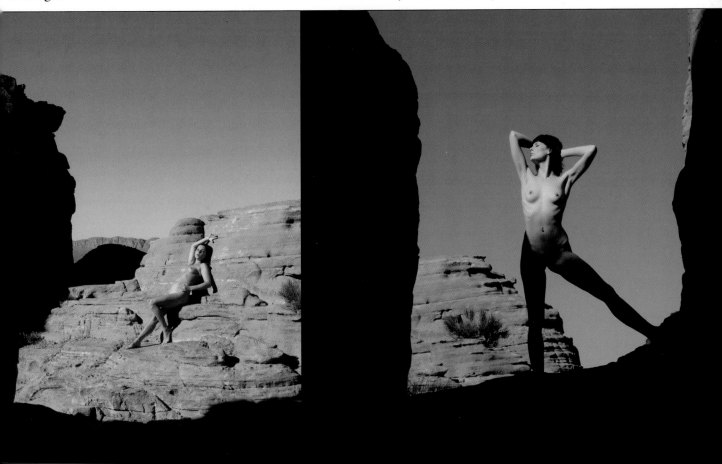

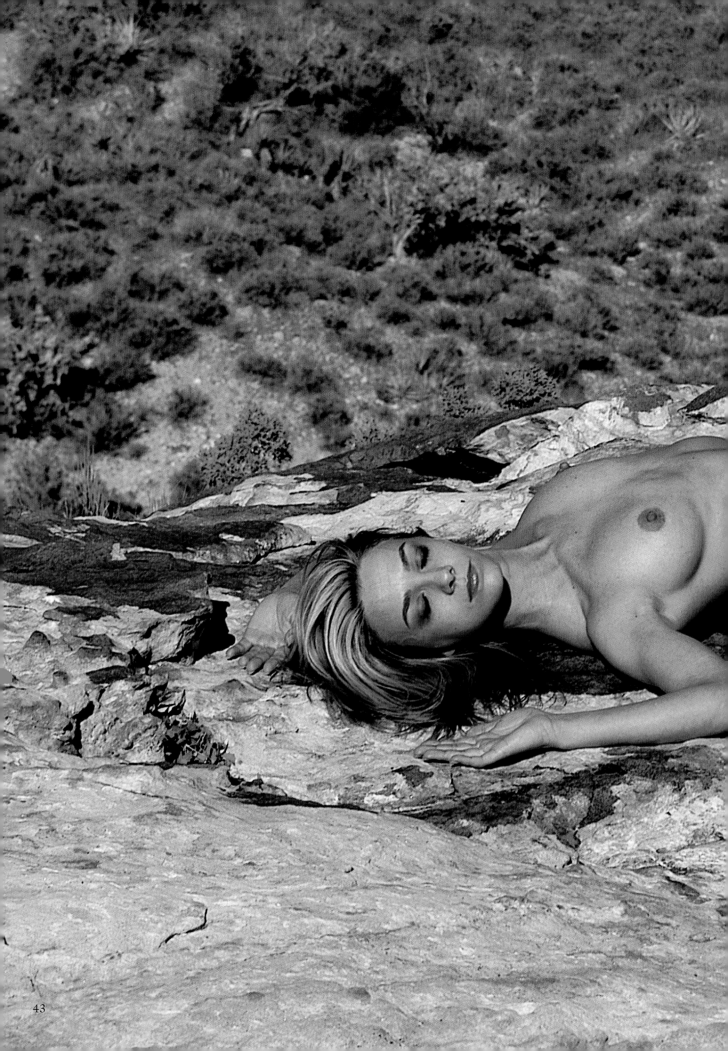

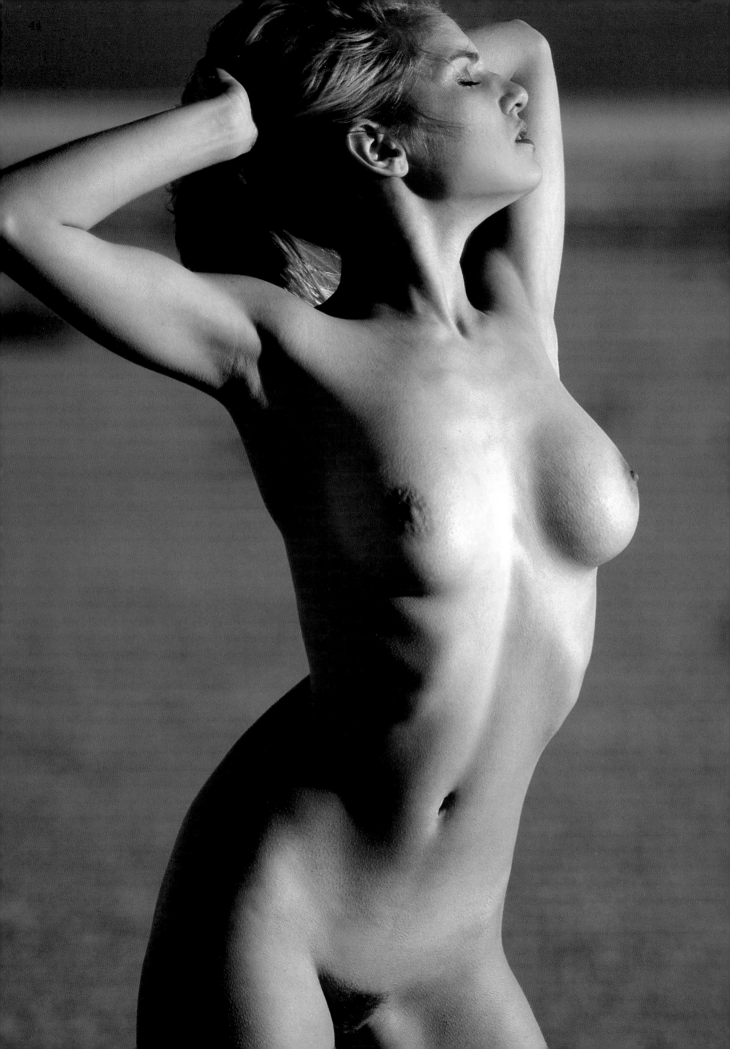

TEXTURE

Image 43 was shot in Red Rock Canyon, Nevada. I love the color and texture that the sagebrush provides in the upper portion of the image and the way that greenery and rock contrast the model's smooth skin.

Summer is an experienced model who has been named *Playboy's* Cybergirl. To produce this image, I instructed her to lay down on the rock. She closed her eyes and struck this highly artistic, sensual pose. Note that the shadows at the small of her back and her legs slim and shape her already taut figure for an even more feminine and chiseled look.

Summer was lit entirely by the mid-afternoon sun, and the image was captured with a Nikon D100 fitted with a 28–75mm Tamron lens.

SIMPLICITY

There's no denying that sometimes a simply executed image makes the best-possible picture. In image 45, Liz clearly dominates the frame in an image that was cropped tightly in the camera.

To create the shot, I took a light reading off of Liz's skin tones and selected an aperture of f5.6, a setting that allowed the background, a dry lake bed in Jean, Nevada, to fall completely out of focus.

The image was made with a Nikon D100 fitted with a 28–75mm Tamron lens.

ACCESSORIZING

Elizabeth brought the scarf shown in image 45 to her session and, once I saw that the coloration in this field perfectly matched her accessory of choice, I felt compelled to create the shot.

Elizabeth is quite tall—perhaps 5 feet, 10 inches—and her pose emphasizes every inch of her frame. She appears quite absorbed by the moment. I positioned her in the left third of the frame to create a little more impact in the image and to show more of the Northern California landscape.

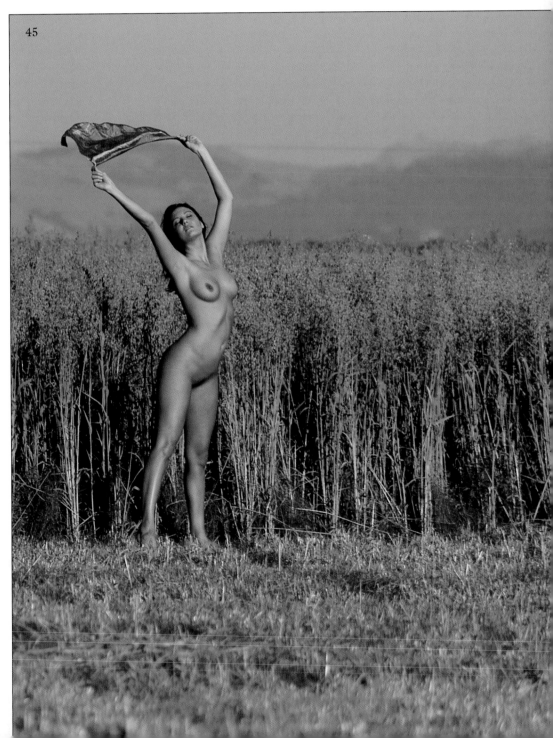

45

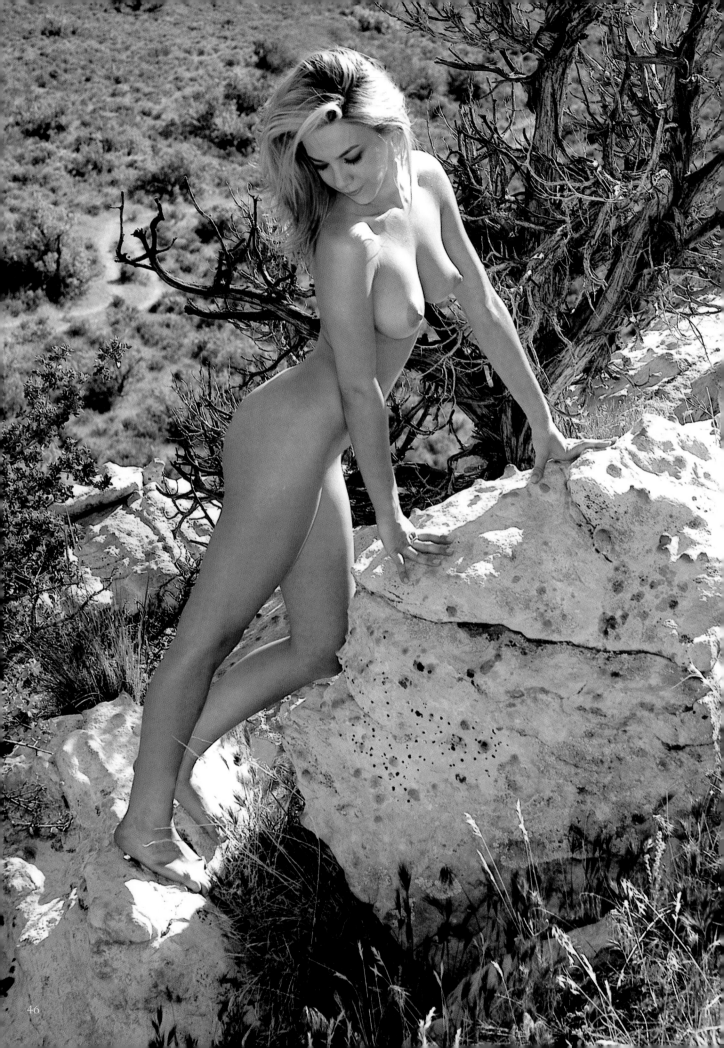

■ POSING MODIFICATIONS

In image 46, the model, Summer, is posed on a mountain in Red Rock Canyon, Nevada.

I think the model has a beautiful body. However, this pose doesn't show off her curves to the best effect. If I had the shot to do over again, I would have asked her to straighten her far leg and slightly bend the leg closest to the camera. This simple posing modification would have really enhanced her form as it appears to the camera.

Since the main light, the sun, was slightly behind and to Summer's left, I used flash fill to supplement the existing light. The rim lighting the sunlight produced on Summer's left side adds a nice touch to the portrait.

The image was made with a Nikon D100 fitted with a 28–75mm Tamron lens.

■ HIGHLIGHT AND SHADOW

Image 47 was shot in Orange County, California, with a Nikon D100 fitted with a 35–70mm Nikon lens. The image was captured in color and was converted to black & white in Photoshop. I requested that Anna Marie sit on the wooden steps and look out toward the ocean, and she developed the pose. Everything about this pose works to strengthen the portrait. There is an inverted triangle shape from her shoulder through her expertly posed hands, and another triangle is apparent from her waist to her pointed toes. By pointing her toes, Anna Marie created space between her thighs and the steps, thereby creating a slimmer, better-toned view of her lovely long legs.

The main light source in the image was the western sun, and I added a little flash in order to fill in shadows and add catchlights—and a little bit of sparkle—in Anna Marie's eyes.

I love the leading lines formed by the steps as they trail behind Anna Marie. The rough-hewn appearance of the steps add an interesting textural element to the image that is supported by the rich texture of the greenery. The varying heights of the brush also creates a soft, undulating line in the image that readily appeals to viewers. Note, too, that the lighter tones in the image appear on the model herself, and the image tones grow darker in the upper third of the image. Because a viewer's eye is drawn first to the lightest tones in an image, the visual importance of the model is accented.

Anna Marie was named *Playboy's* 40th Anniversary Playmate.

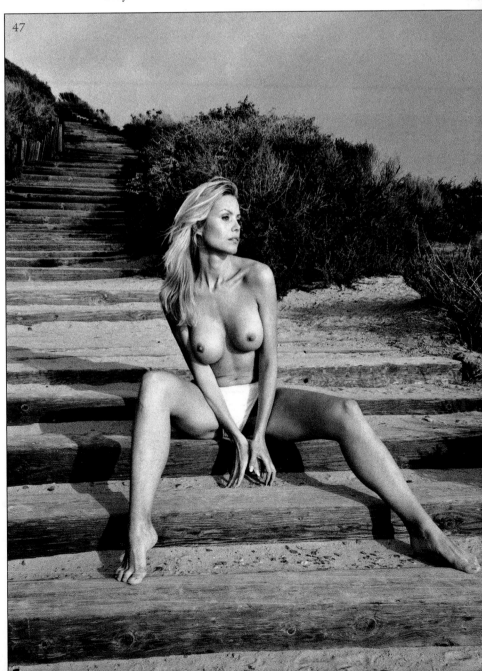

47

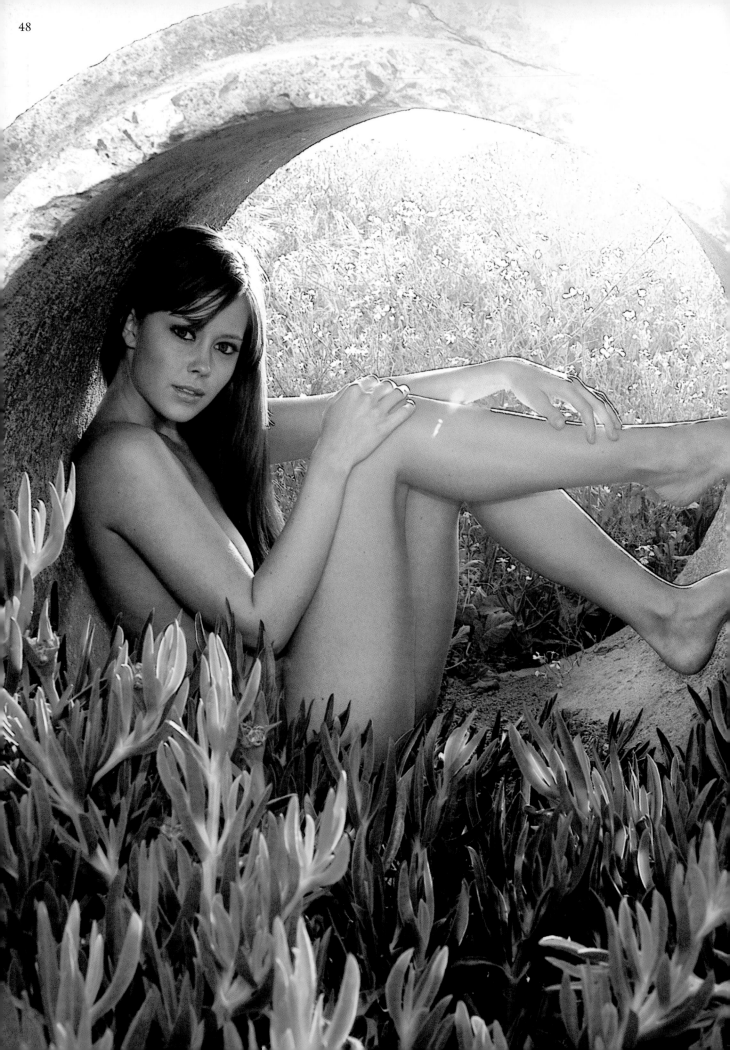

COMPOSITION

Image 50 was captured on the back of an old trailer in the middle of a field. I used my Nikon D100, fitted with a 28–75mm Tamron lens and created the image in all natural light, with Caitlin turned to face the sun.

The composition places the main area of focus in the image—the subject's face—at the top-left power point, and her body forms a soft triangular shape that's pleasing to the eye. Her position in the frame also allowed me to feature the interesting lines and textures of the old farm equipment.

Notice that with the camera height at which the portrait was made, the horizon line falls just above Caitlin's head. Be sure when creating such images that the horizon line does not cut across your subject's face or neck, as this can be distracting to viewers.

DRAGLINE

I've been lucky to locate a number of great, beautifully weathered examples of old farm machinery—a favorite prop—or backdrop—for my nude images. This equipment provides so much visual interest in the images; the rusty coloration almost looks like a painter's canvas.

Images 51 and 52 feature the same prop—a dragline—and the same model, Julie, who was named *Playboy*'s Playmate of the Year in 1995.

Both images were made during a single session with only available, mid-afternoon light. I used a Canon PowerShot G1, my first digital camera, to capture the images. This particular camera is a point & shoot model with a fixed lens; this fact simply goes to show you that the success of an image depends more on the photographer's vision and the chosen subject than on the equipment that's used to capture the shot.

CREATIVE CONTROL

I used to have my models come into the studio, where we would look at my work and begin to conceptualize the elements of a session together. I don't do that much anymore. Today, models see my images on the Internet. They like what they see, and that's why they call. They depend on me for my creative vision but let me know what range of image types they are comfortable with. From there, I'm in control of developing the artistic aspects of the session.

The models typically bring a selection of clothing along for their session. They have a good sense of what flatters their forms, and clothing that they feel good in adds to the success of an image. We typically review the clothing selection together to determine whether it will suit the artistic concept I have in mind.

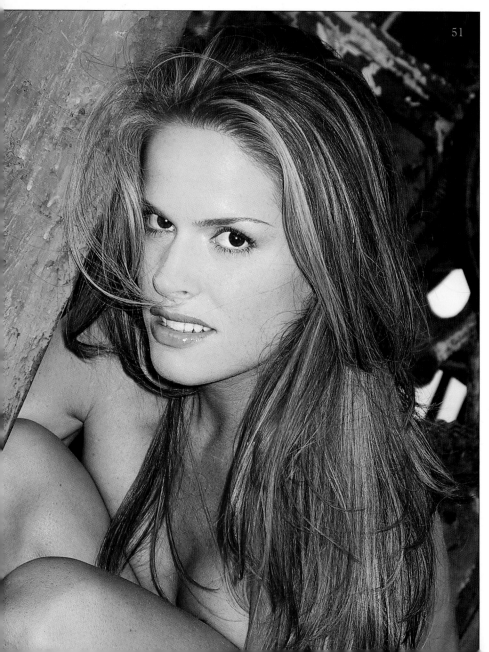

51

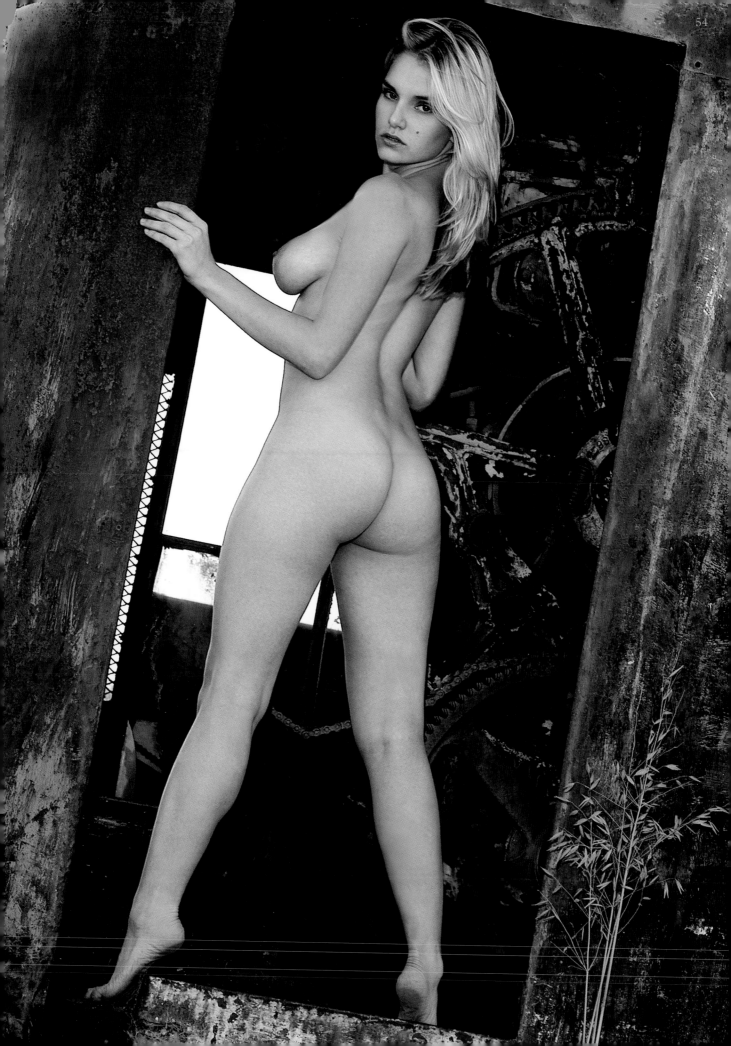

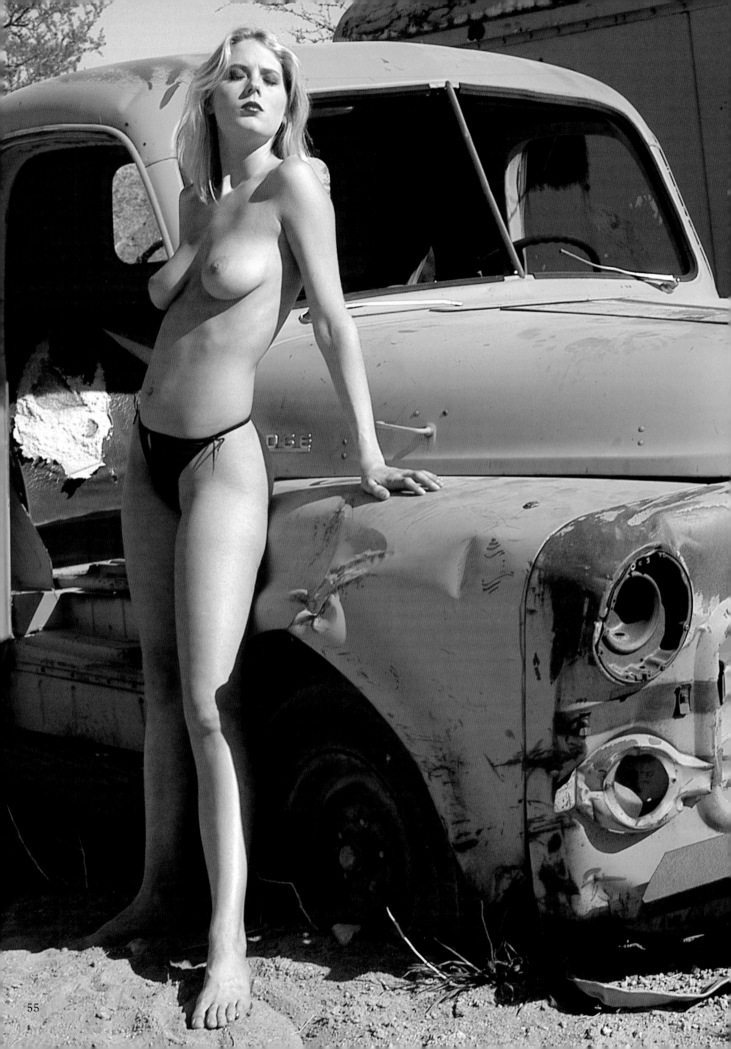

■ VINTAGE STYLE

What a great find the trucks shown in images 55 and 56 were! Their vibrant color, torn interiors, and dramatic shapes would have made great photo subjects on their own, but when paired with this beautiful, semi-nude model, the storytelling aspects of the scene were further enhanced.

In portraiture, clothing visually defines a subject's personality and helps to create a particular mood in the image. In this line of work, you can reduce or remove the impact of the clothing, allowing the background and the model herself to completely tell the story.

In image 55, Jennifer was positioned at the far left third of the composition, allowing the trucks to feature prominently in the scene. She created the pose, and I had her lift her head to prevent dark shadows on her face.

■ PERSPECTIVE AND VERSATILITY

To capture the best-possible variety of images during a single session, it's important to capture closer *and* longer shots during each session and to consider a variety of camera heights and angles. In image 56, the trucks take on more of a supporting role in the composition. The closer shot and tilted camera angle put a new spin on the location and allow the viewer to focus solely on the model's shape and contemplative expression.

Photographing Jennifer at a slight angle to the camera produced a flattering view of her breasts, waist, hips, and upper legs. No matter how thin or well-proportioned your subject is, try not to photograph her square-on to the camera. Also, be sure that the model's arms are held slightly away from her torso and that there is a slight separation between the legs; this makes the body appear more slender.

Images 55 and 56 were made in early-afternoon sunlight with a Nikon D100 and a 28–75mm Tamron lens. Note the difference in the tonal values of the trucks in these photos. Image 56 was brightened in Photoshop.

In image 57, Julie illustrates yet another look that I've captured in this one location. This full-body shot shows off her physique and the interesting, texture-rich prop. The image was captured with a Canon PowerShot G1 and was toned using the Hue/Saturation command in Photoshop. Presenting an image in black & white can simplify an image, allowing the viewer to focus more attention on the shapes and textures in the image. Here, the contrast between Julie's skin and her immediate background focus attention on the model.

57

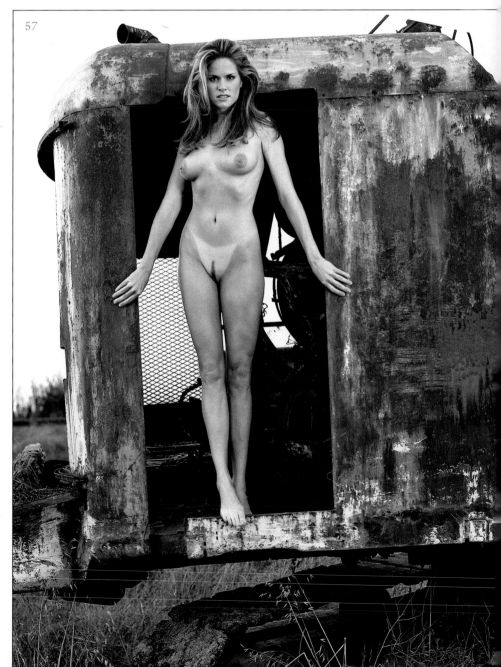

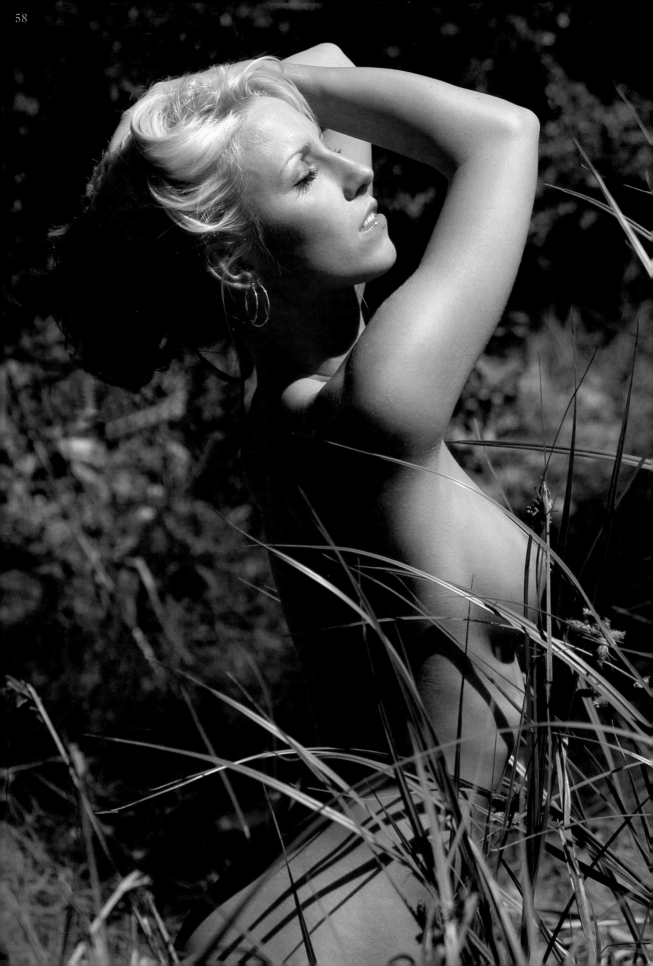

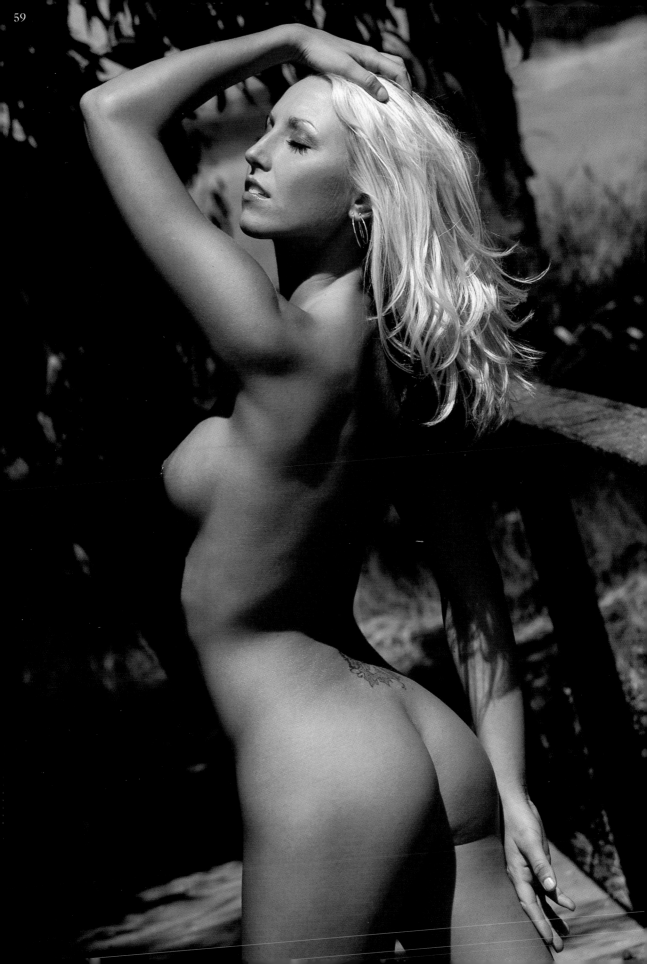

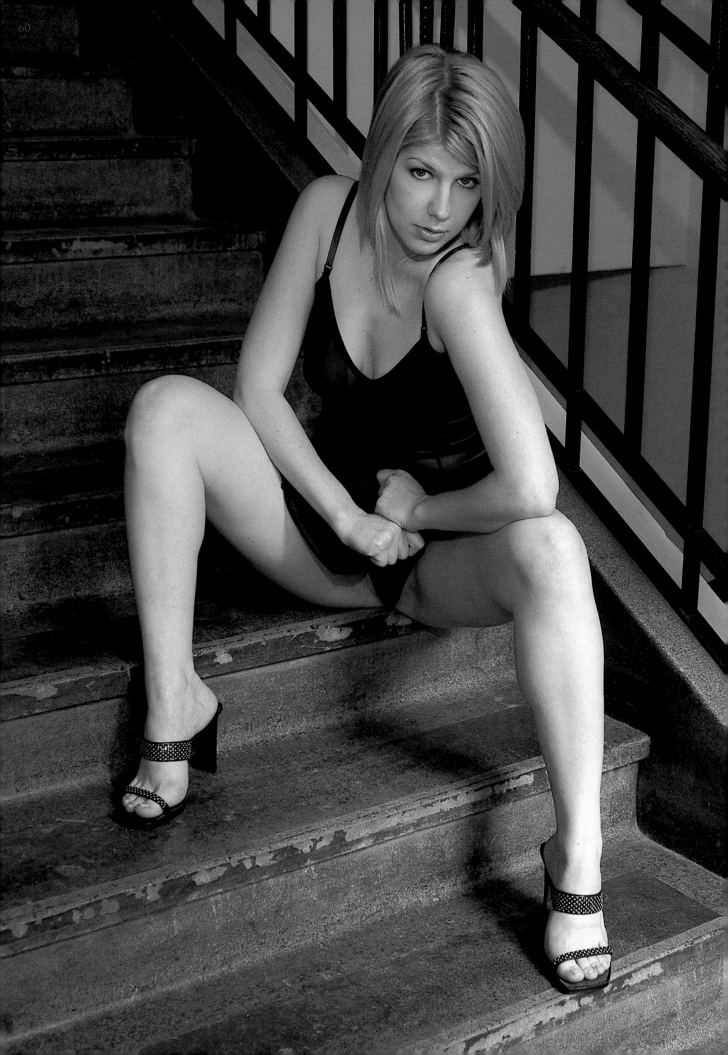

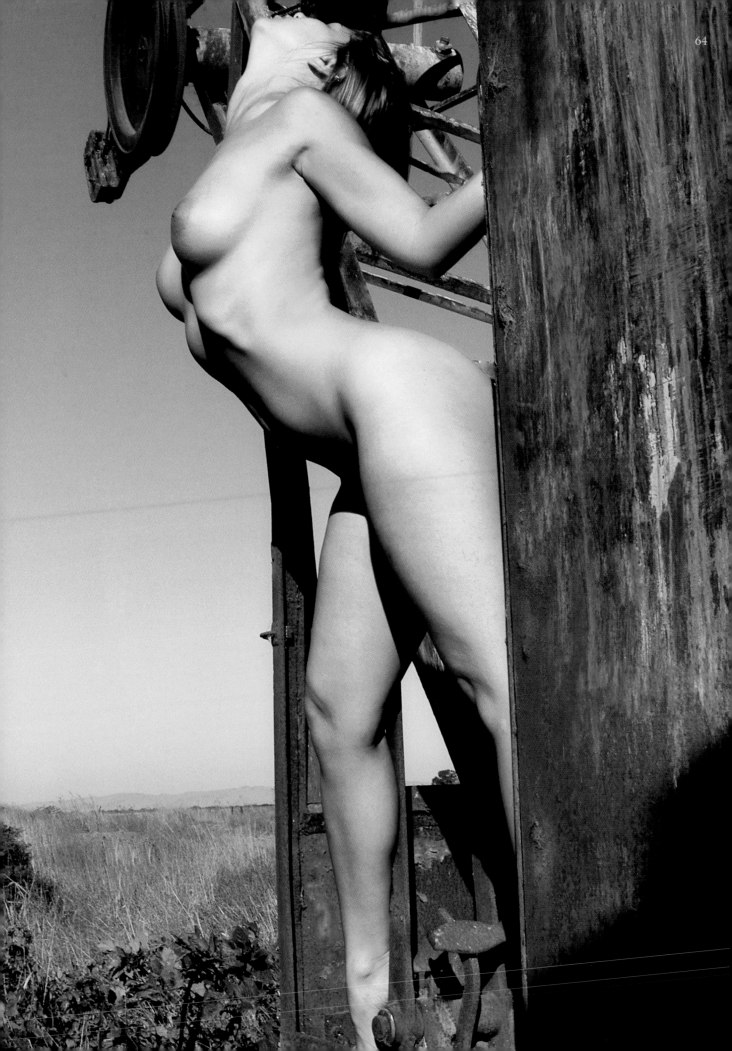

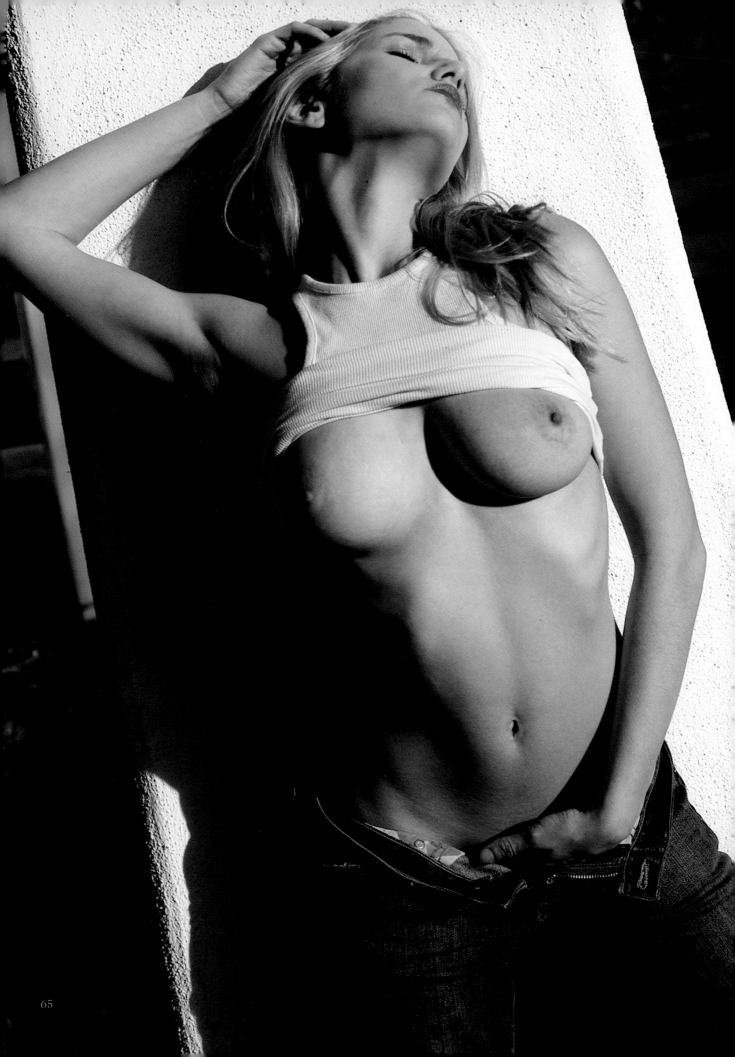

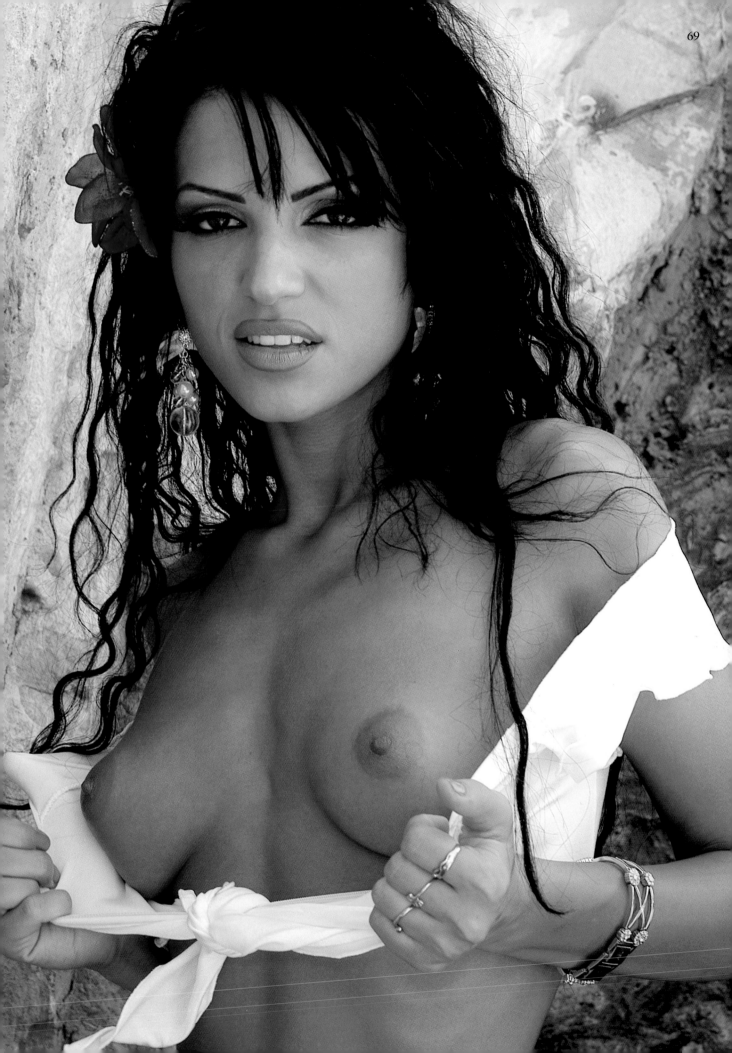

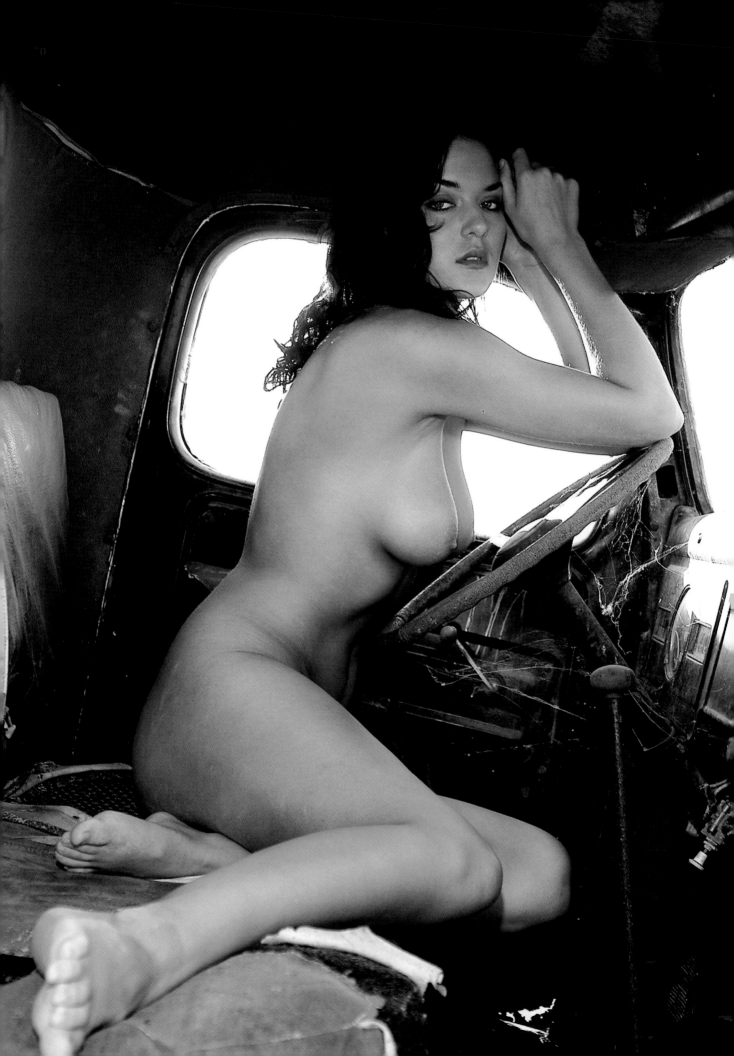

◼ GROUP PORTRAITS

Image 72 features three beautiful models—from the left, they are Heather, Mindy, and Julie. I was conducting a workshop in Chester, South Carolina, when I decided to create this image, which I had conceptualized some time before.

I asked the models to stay once the workshop concluded. To set up the shot, I had them pose on the porch of this building, which once housed plantation workers. The rocking chair was readily available and perfectly suits the scene.

The image was shot in late-afternoon sun, and I used two large white reflectors to bounce light back in toward the models.

The shack-like abode has seen better days, and with the models positioned with such poise and confidence, the elements in the image combine to create a storytelling image that suggests a backcountry house of ill repute.

This group portrait has several strong compositional elements. The staggered heights of these three models—a key concept in group portraiture—leads the viewer's gaze through the image. Each model's pose is unique, a feature that satisfies the viewer and produces a more natural, spontaneous feel in the image. The bright-white areas of the image are concentrated in the center of the portrait and demand attention, too. The sepia toning, created with Photoshop's Hue/Saturation feature, imparts a pleasing warmth and a real period feel.

I used a Nikon D1X and a 35–70mm Nikon lens to create the image.

◼ TONING FOR EFFECT

Tonya, the model shown in image 73, was photographed in a building on the premises of a South Carolina State Park. My assistant stood guard to ensure that no one walked into the room while we were conducting the shoot.

I love this image; with its dramatic lines, highlight and shadow areas, and the rich texture of the building's walls, it was a good candidate for color to black & white conversion. I toned the image using Photoshop's Hue/Saturation command to achieve a warmer feel. Though this is a semi-nude image, it has a sort of storybook feel.

Note that the image was cropped to include more "white space" in the direction of the model's gaze. This is a more effective composition than would be achieved by centering the window in the frame.

A Nikon D1X and a 35–70mm Nikon lens were my tools of choice in creating this image, which was made using only natural light.

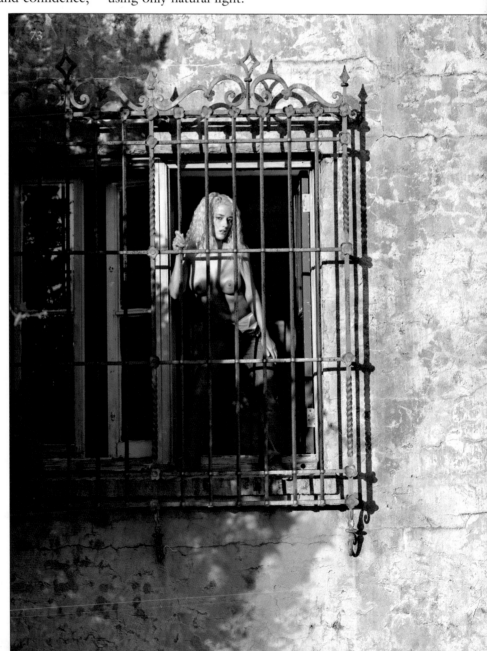

73

◼ A FAVORITE PROP REVISITED

Image 74 is remarkably successful, being that this was Roxie's first nude shot.

To create the shot, I had the model lay across two side-by-side culverts, with her hips positioned between them to produce a figure-flattering arch in her back.

The image was shot at midday, with the sun high in the sky. I used a Nikon D100 and a 28–75mm Tamron lens to capture the image, which I cropped tightly in the camera. The resulting portrait is very artistic and highly sensual.

◼ GOLDEN HOURS?

Many photographers advise shooting only during the "golden hours"—from sunrise to the hour after sunrise and an hour before sunset to sunset, a time when the quality of light best flatters the subject. Direct, overhead light can create unflattering shadows. However, you'll note that most of my images were made outside of the "golden hours." My thinking is, so what if the model needs to turn her face upward toward the sun and close her eyes? So what if you need to position the subject under an overhang to get a softer quality of light

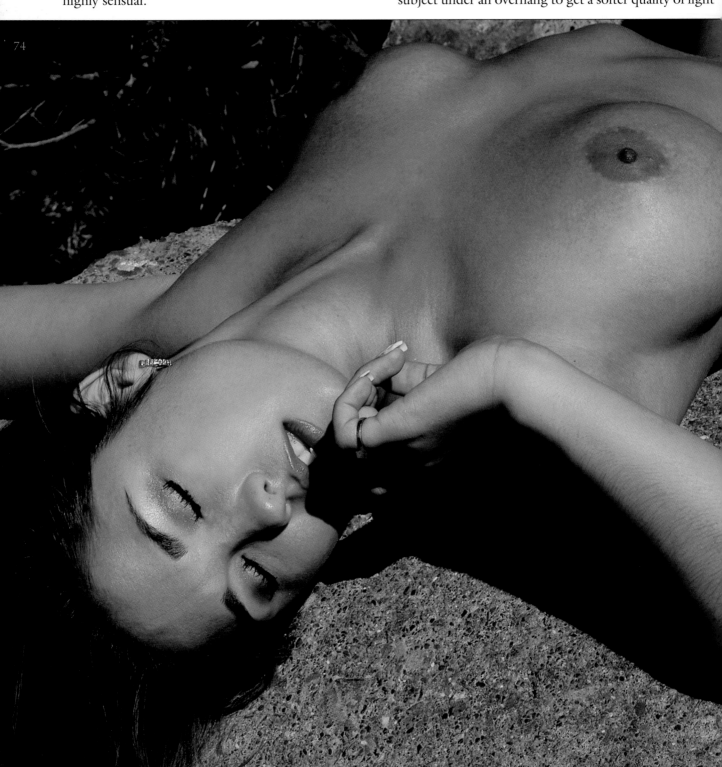

74

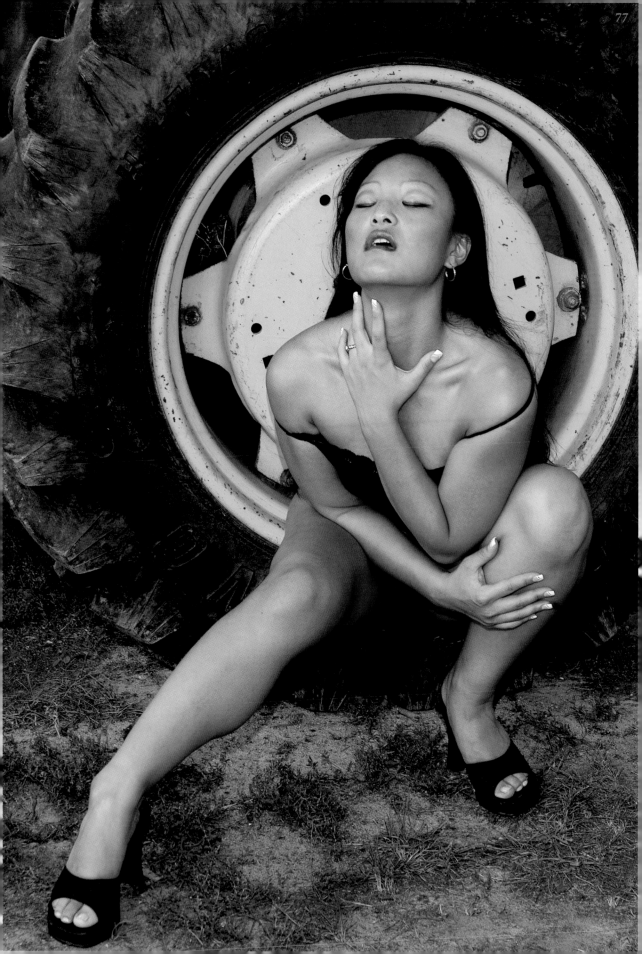

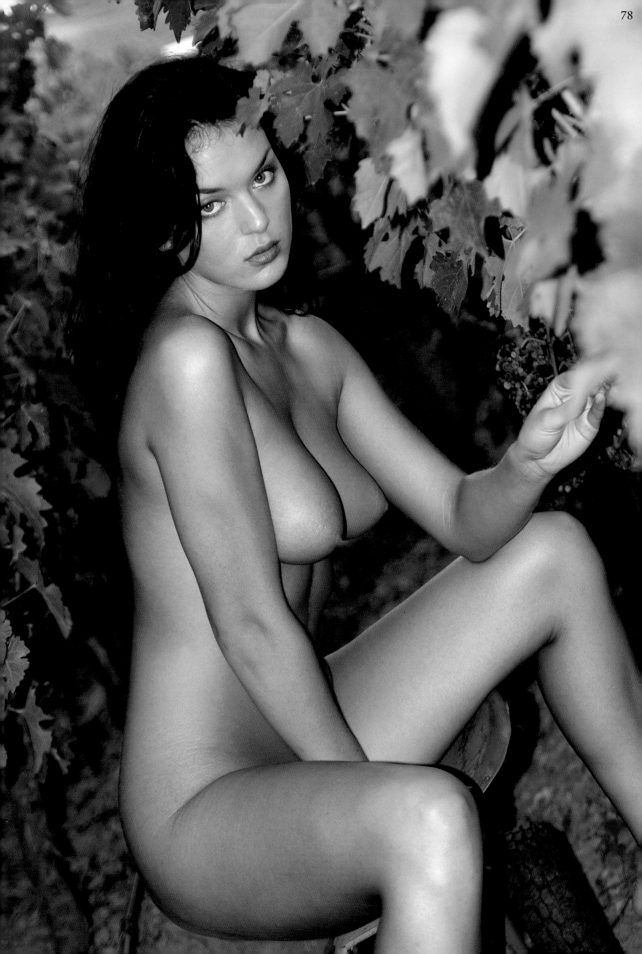

■ UNINTERESTING BACKGROUNDS

Images 83 and 84 were shot in a hotel room in Baton Rouge, Louisiana. While image 83 shows a longer shot of the model than does image 84, both were cropped close in the camera to eliminate as much of the uninteresting background area as possible.

Sarah Kate has beautiful, striking, and emotive eyes that really seem to "jump" in contrast to her ivory skin, and her eye contact with the lens in these two images is quite provocative.

A Nikon D100 with a 28–75mm Tamron lens was used to capture both images, and an on-camera flash added the catchlights and resultant sparkle in her eyes.

■ GUESTS ON THE SHOOT

When I schedule a shoot, whether on location or in the studio, I don't place any restrictions on the model bringing a friend along. The only thing I don't like (and discourage) is models bringing along their boyfriend or husband. It's not that I feel they'll get in the way but that it makes me feel less relaxed and less able to create the images I want from the shoot.

An important factor in my images is the focused artistic relationship between the model and the photographer. With a boyfriend or husband on the set, this gets lost to some degree because the model may feel self-conscious or look to him for approval. With female friends present, that same problem doesn't seem to occur.

Ultimately, I prefer a one-on-one shoot, and since most of my models come to me through referrals from other models, they typically don't mind arriving alone.

■ A TWO-LIGHT SETUP

Image 85 was created on location in a hotel room in Buffalo, New York. The model, April, was illuminated with two softboxes: One was placed to camera right and behind the model and produced rim lighting on her knee. The other was placed about 45 degrees to camera left.

The pose was my idea. I placed the white garment behind her head to create separation between her hair and the dark-green carpet.

The carpet and tapestry-like upholstery on the chair add a bit of color and texture to the image but do not visually overwhelm the subject.

The image was captured with a Nikon D100 and a 28–75mm Tamron lens.

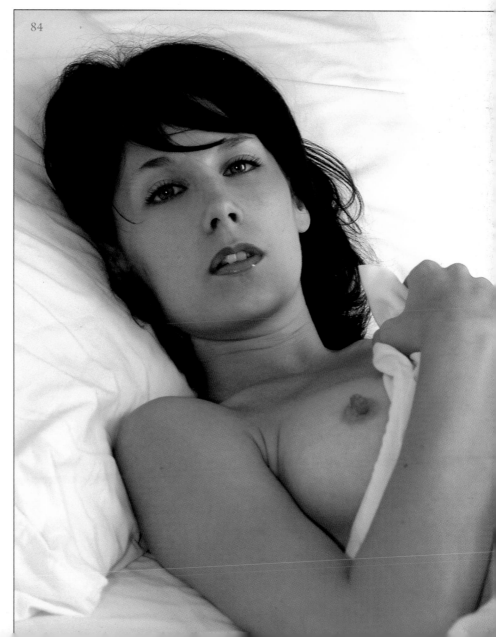
84

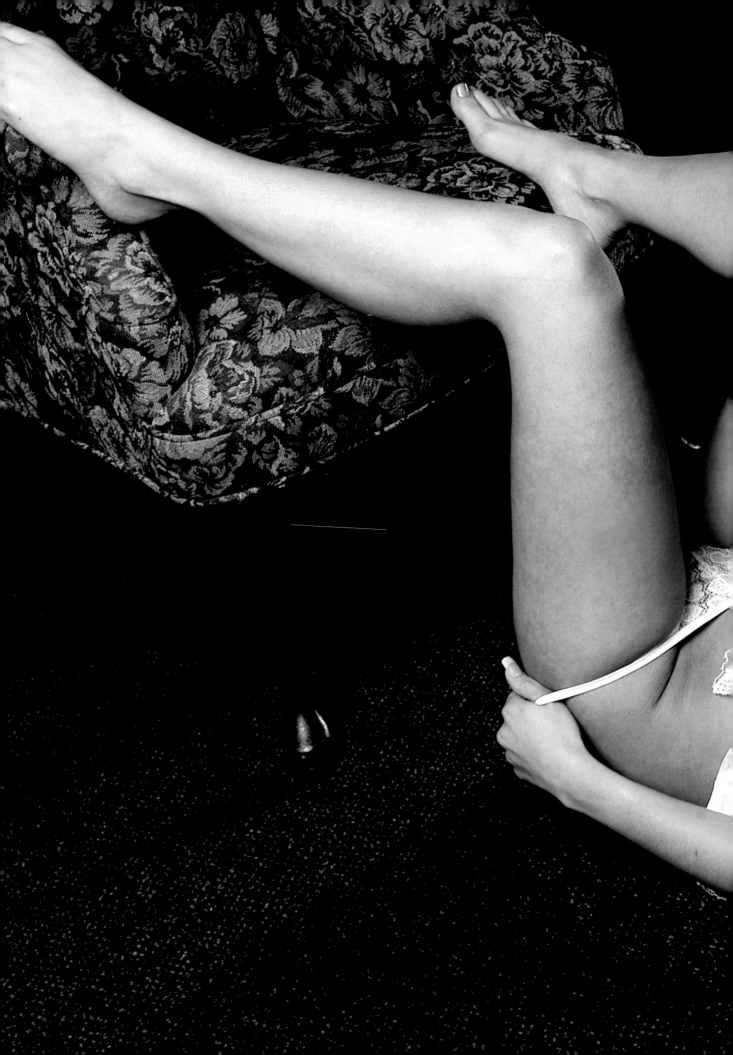

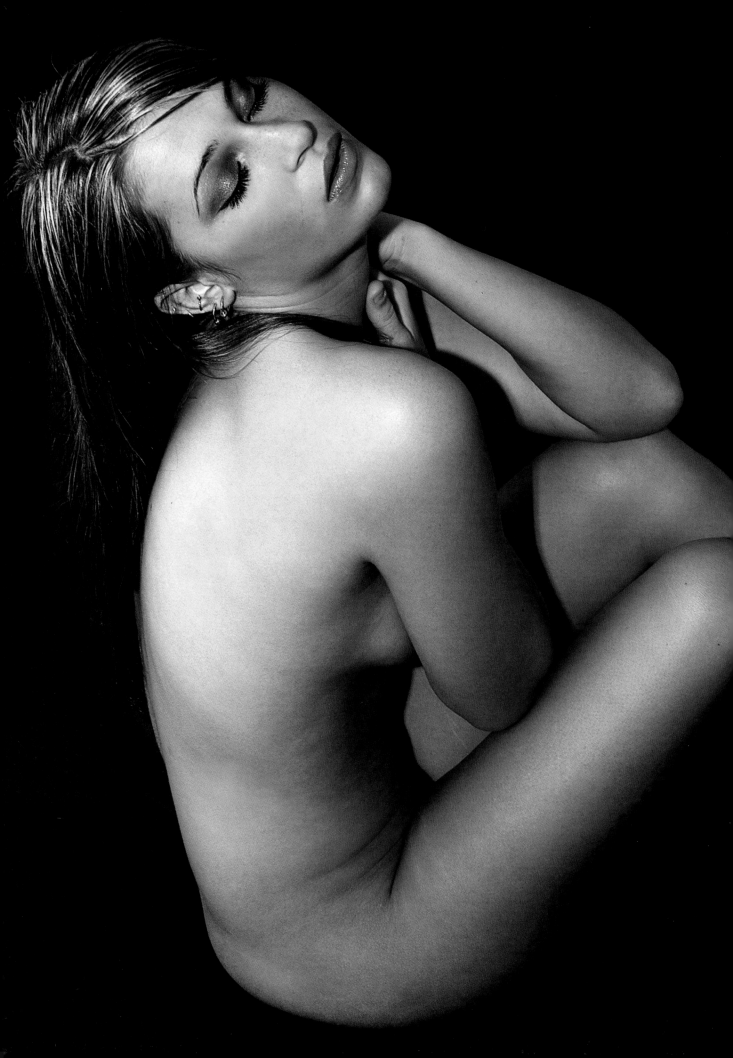

■ A HIGHLY ARTISTIC POSE

Caitlin was interested in creating a modest image. She didn't want to fully expose herself to the camera and came up with the very fluid, sensual, and artistic pose shown in image 86. I had her tip her head backward to slightly refine the way she appeared in the camera.

This image was taken in my office. I draped the black velveteen fabric over the platform on which she is seated and extended it up the wall.

Caitlin was lit with ambient light and on-camera flash. The lighting brought out the sexy shimmer in her eyeshadow and full, sensual lips.

■ MAKEUP

In most of my color images, I prefer a more natural, "girl-next-door" look. For black & white glamour portraits, however, the features are made more prominent with bolder/darker colors.

In image 87, Tonya's dark lip color makes her well-defined mouth a focal point in the image, and the tone creates a lovely contrast with her pale skin and light hair. Her dark eyes and eyebrows required much less color, but she added some eyeliner, shadow, and mascara to create more definition and balance her strong lip color.

While some photographers hire makeup artists for their models' sessions, I don't find the practice necessary. Most models do a very acceptable job of applying their own makeup. There are two great benefits in this: there's a cost savings, and the model has increased control over the way she will appear in the photographs. Of course, you can always recommend certain tones—like a pale, shimmery lip color or a bolder, classic red, for example.

■ IDEAS THAT WORK

The setup for image 88 was quite streamlined. I placed a strobe with a shoot-through umbrella at camera right, and Helena developed the pose and turned her head to make eye contact with the camera. The angle of her body in relation to the lens is dramatic and engaging. The triangular shape formed by her arm frames her face, and the uninteresting background is largely cropped out of the image.

Don't allow yourself to get into a rut, capturing the same images over and over again with different models. Magazines are filled with a wide variety of enticing portraits, made by the very best shooters. Evaluate a bunch to find creative and flattering posing ideas, evocative photo concepts, and lighting setups that work. It takes only a little analysis to figure out how to duplicate or modify the shot to get the look you're after.

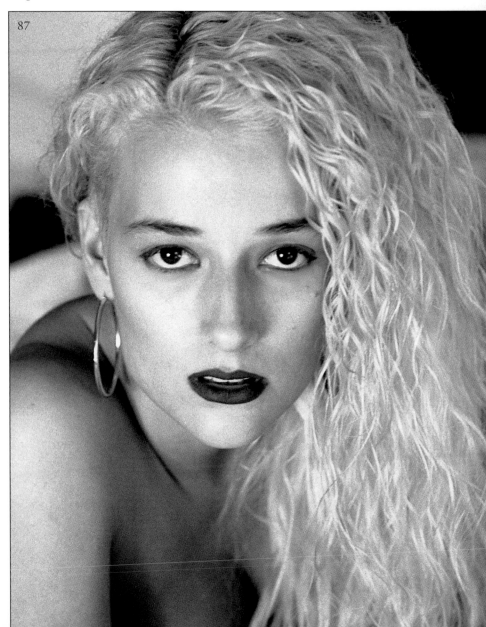
87

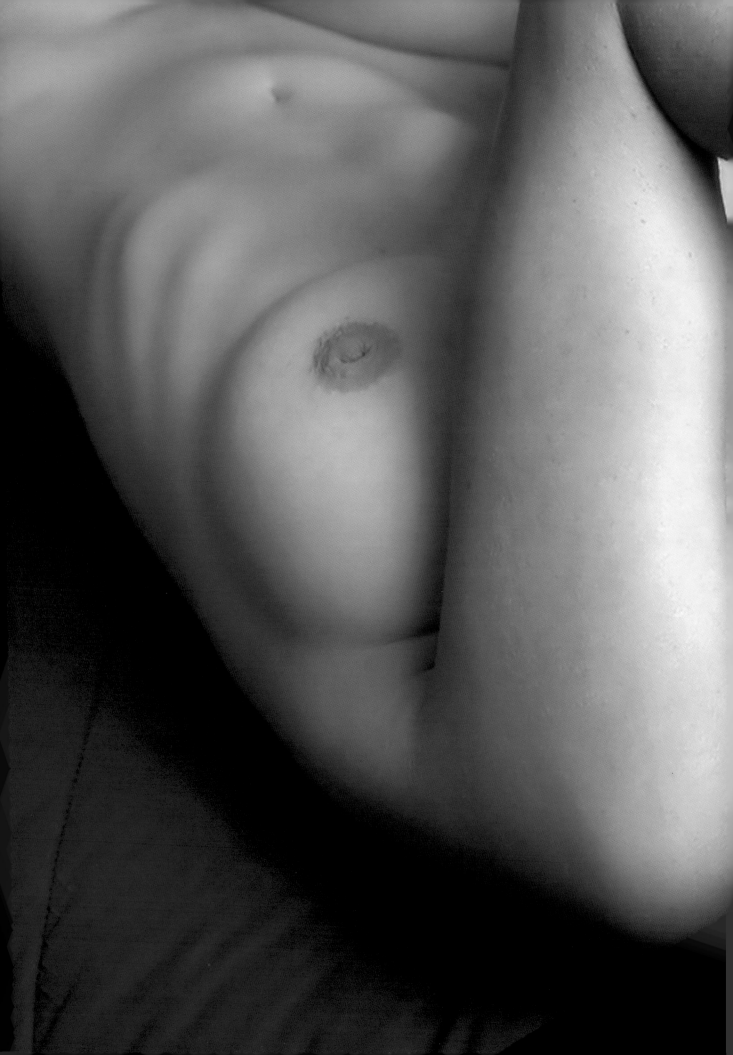

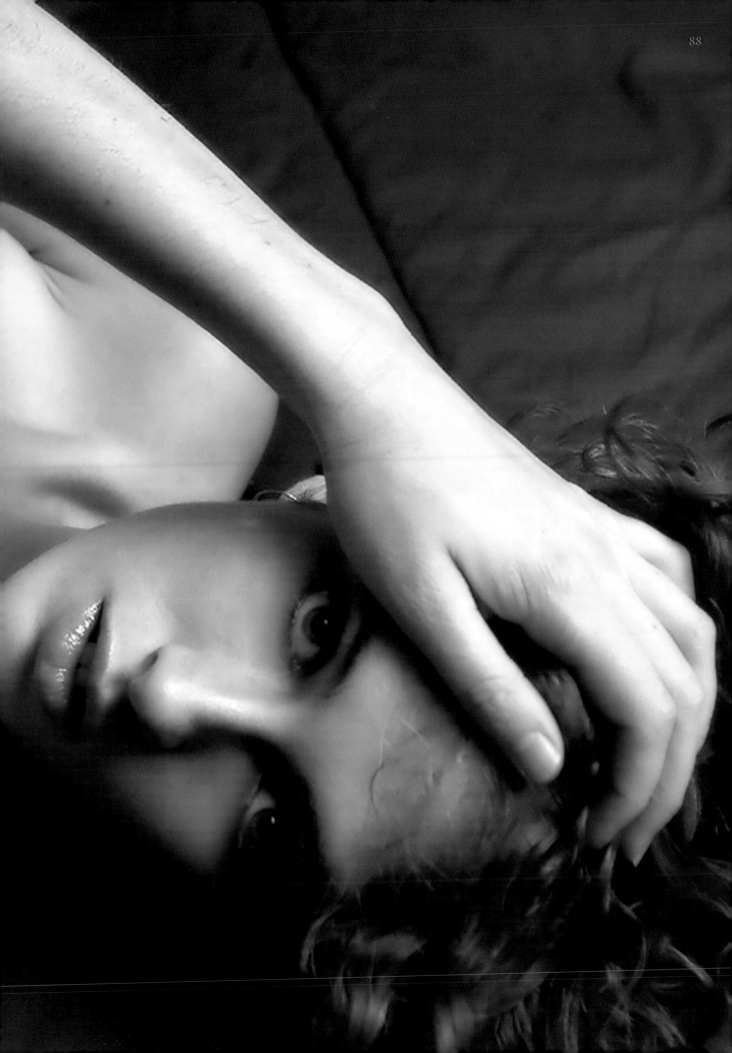

■ THE "SUBMISSIVE" HEAD POSE

Natalie slipped her bra off for image 89 and came up with this playful pose, which is all at once both suggestive and slightly demure. The image was cropped at the fullest part of her left breast, and though we can see more of the form of her right breast, it's largely hidden by her long hair. In posing, tipping the head toward the shoulder nearest the viewer is considered the "feminine" or "submissive" pose. By tipping her head toward her far shoulder, she achieves a more assertive pose, and her expression, from her smile to the sparkle in her eyes, has a real "come hither" look. The black background allows us to focus on her expression and sexuality.

The image was lit with an on-camera flash and was captured with a Nikon D100 and a 28–75mm Tamron lens.

■ PARALLEL DIAGONALS

In image 90, Helena's torso appears just shy of square to the camera. The significant bend in her left leg produces a wonderful sloping curve that runs from her waist through the bottom edge of the image. The red tank top provides a needed splash of color, and having Helena hold it in this manner adds an interesting diagonal and gives form to her hands. Traditionally, it's a good idea to present a less prominent view of the hands to the camera (as is exhibited in the positioning of the model's left hand). While in this case, Helena's right hand is presented in a fist-like position, and all of her knuckles point toward the camera, the prop makes the hand position work. Note that there is space between Helena's arms and torso; this flatters the model's arms and ensures a slimmer presentation throughout the upper body.

Note that the tilt of Helena's head, the line of the tank top, and the diagonal from her waist through the near hip are all quite similar and add a visually pleasing continuity to the image. Also notice that Helena uses the exaggerated pose of her body to nicely fill in the space between the left and right doorjamb.

This image was shot with a strobe fitted with a 30-degree grid that was placed to camera left. Though they do draw attention, I purposefully left the lights on in the background of the portrait, because I liked the intensity of the wall color with the lights turned on.

The image was made with a Nikon D100 fitted with a 28–75mm Tamron lens.

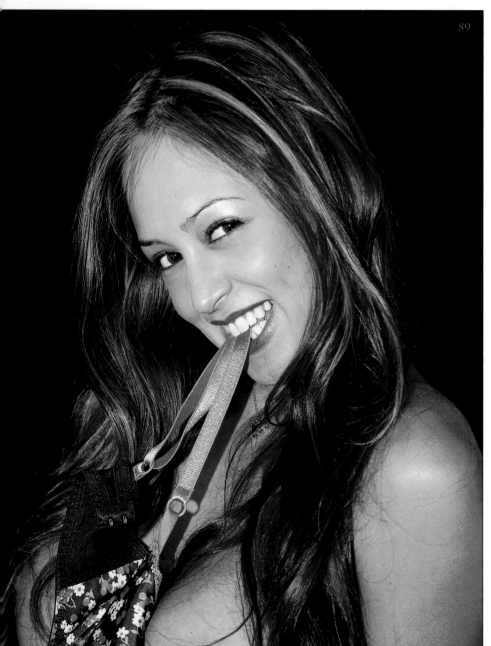

89

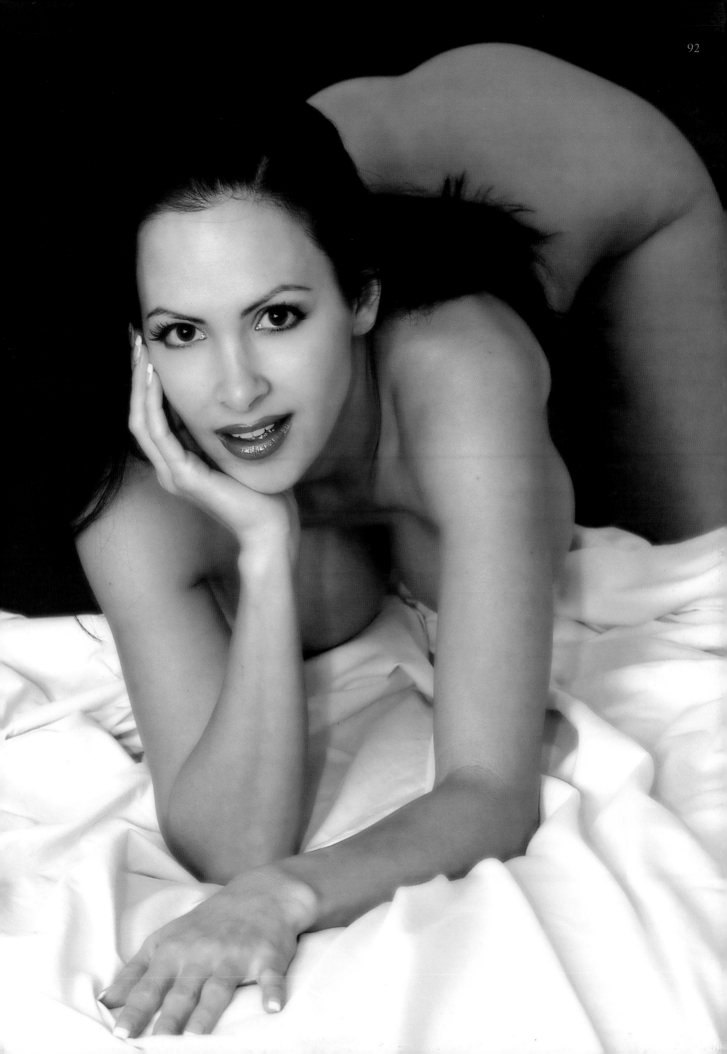

MODIFIED LIGHT

Image 91, created in Niagara Falls, New York, shows an interesting lighting effect.

There were two lights used to create this image of Tracy. I taped a Bastard amber gel on the first, a strobe placed at camera left, to warm Tracy's skin tones. This light was directed through a cucoloris, or "cookie," a mask used in front of the light that can be used to mimic the effect of sunlight through leaves (or to create a similar pattern of light and shadow). The second light, placed closer to the subject on camera left, was fitted with a 3-degree grid and directed light onto her face. (You can tape two 10-degree grids together to produce a 3-degree grid.) Illuminated with this light, Tracy's face is slightly lighter in tone than the rest of her body.

Tracy's pose is well executed. Her raised left leg conceals her pelvic region, and the angle and lines it creates add visual interest. Her hands are beautifully posed and are not too prominent in the frame. The space between the model's left arm and her torso and the space between her left leg and the newel post allow for the most slimming presentation of her lovely figure.

FLATTERING THE BUSTLINE

In image 92, Malisia was posed on a platform made to look like a bed. The portrait was made with a Nikon D100 and a 28–75mm Tamron lens, with on-camera flash. This is Malisia's pose, and her personality is evident in the great facial expression shown here.

Malisia's long, elegant fingers gently frame her face and draw attention to her beautiful, dark eyes. By leaning over in this way, she was able to ensure that her breasts look as full as possible. Note that the position of her arms and the careful positioning of the strategically rumpled sheet obscure a more complete view of her breasts and provide a degree of modesty.

SELF-ASSIGNMENTS

Self-assignments can provide a creative spark. I decided to incorporate one of my own button-down blue shirts into a wide array of scenes (many such images appear in this book), giving myself a reason to shoot, and image 93 was one result.

Martina, shown in images 93 and 94, was *Penthouse* Pet of the Year 2005.

In image 93, she is standing behind the door that leads from my studio to my back room. The lighting for the image came from a 4x6-foot softbox, placed to camera left.

The vivid colors in the door and the punch of added color the shirt provides are beautiful against her pale skin. The camera angle produced added interest in the image, and the bright diagonal lines attract the viewer to her face, breasts, and pelvic area. Her pose is delicate and somewhat mysterious, and Martina's expression is well matched to her body language.

The image was made on a Canon PowerShot G1, a point & shoot camera with a fixed lens. I did some work in Photoshop to remove a reflection from the glass.

While this presentation is quite effective, I've also cropped this image as a head shot, and it has earned many accolades.

While image 94 has a drastically different look than does image 93, the two portraits were made with the same equipment, during the very same session.

Martina's pale skin tones and hair are shown in sharp contrast to her low-key surroundings in this portrait, which was captured in color and converted to black & white in Photoshop.

A CLASSICAL APPROACH

My images are sensual—and yes, sometimes sexy—without being blatant or distasteful. I like to show the softness and beauty in the female form, and my ability to do so has earned me much esteem in the industry.

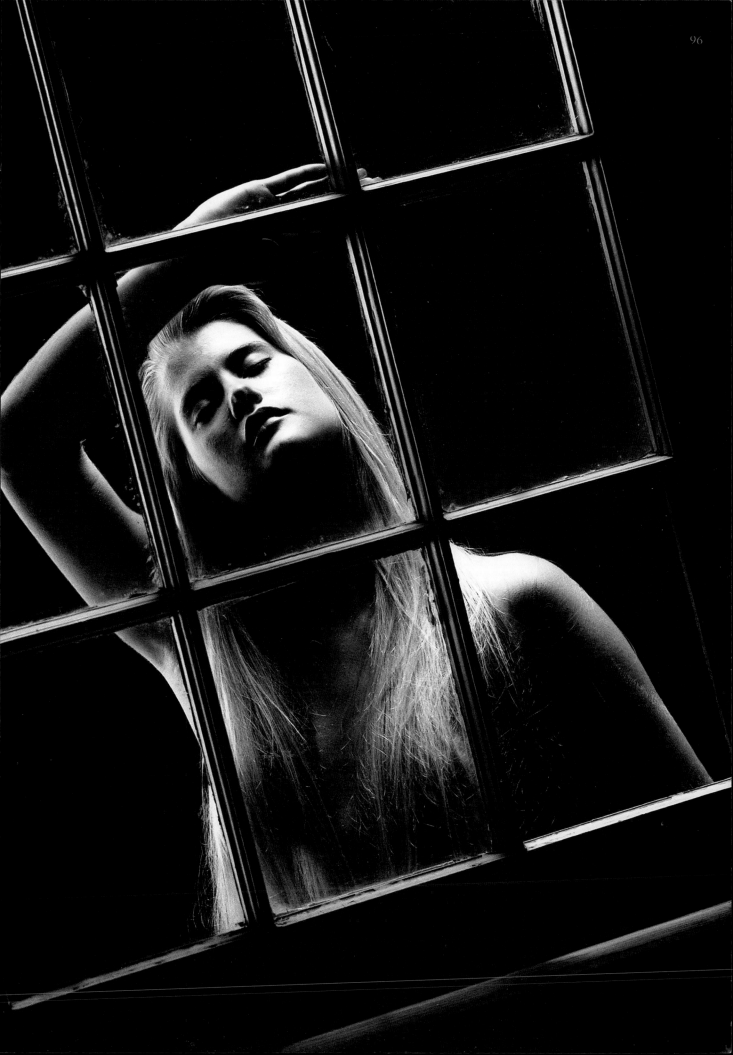

6. COUPLES

When you're creating an intimate portrait of two people, there are certain precautions that should be taken. Whether the two people involved have an existing relationship or are meeting for the very first time at the shoot, I always ask the female whether or not it is okay for the male to place his hand in a particular way on her body. Subject comfort is absolutely critical to getting a good image, so taking a few moments to ensure the model is comfortable is worth the time it takes out of the shoot—even when you feel confident that the couple has a close and perhaps physically intimate relationship.

■ HEIGHT DIFFERENTIAL

Rebecca and Ellis, the couple shown in image 97, were photographed in a hotel room in Charlotte, North Carolina. The image was made with ambient light and one strobe, placed to camera right. The couple are actually boyfriend and girlfriend. This fact made the posing for the particular image appear quite natural.

The protective quality of the male's body language, the way that the subjects' hands tenderly meet, plus her kiss on his cheek speak volumes about the closeness of their relationship.

Note that while Ellis's head is bent toward his girlfriend's body, there is still a noticeable height differential between the two subjects. This is critical when photographing two or more subjects, as it helps to draw the viewer's gaze through the frame.

This portrait was made with a Nikon D1X fitted with a 35–70 Nikon lens.

■ PROXIMITY

Image 98 was captured in Jean, Nevada, on a dry lake bed. It was quite chilly, but Liz and Derek were great sports.

The pose was my idea. I wanted to showcase the power of the man holding this graceful, feminine shape. They look mutually protective. I like the feel that Liz's head resting on Derek's cheek creates; the small gesture seems to depict a sense of security. While the pose works overall, if I had a chance to reshoot the image, I'd have had Derek close up the space between his fingers over Liz's hip in order to show more of her body and make his hand less prominent in the frame.

Because Derek is much taller than Liz, I had her stand on her tiptoes in order to position her face nearer to his, a posing adaptation that creates the appearance of a closer emotional connection and tightens and lengthens Liz's legs as well.

The image was shot on a Nikon D100 with a 28–75mm lens.

■ PROFESSIONALISM

Image 99 was made in Red Rock Canyon, Nevada with all natural, late-afternoon light using a Nikon D100 and a 28–75mm Tamron lens.

Summer and Rico had never met prior to the shoot, but their professionalism, skill in posing (the couple designed the pose themselves), and great attitude allowed for this terrific result.

The image is a study in contrasts. Summer's skin is very pale in comparison to Rico's; his larger frame overpowers her smaller form, and his gaze is focused upon her body, though her head is turned the other way. Rico's stance and pose are strong and powerful, and Summer's curves and body language are quite graceful.

The landscape is important in the image, and the texture of the various natural elements add interest and color. Note that the placement of the mountain in the frame does not distract from either subject's face.

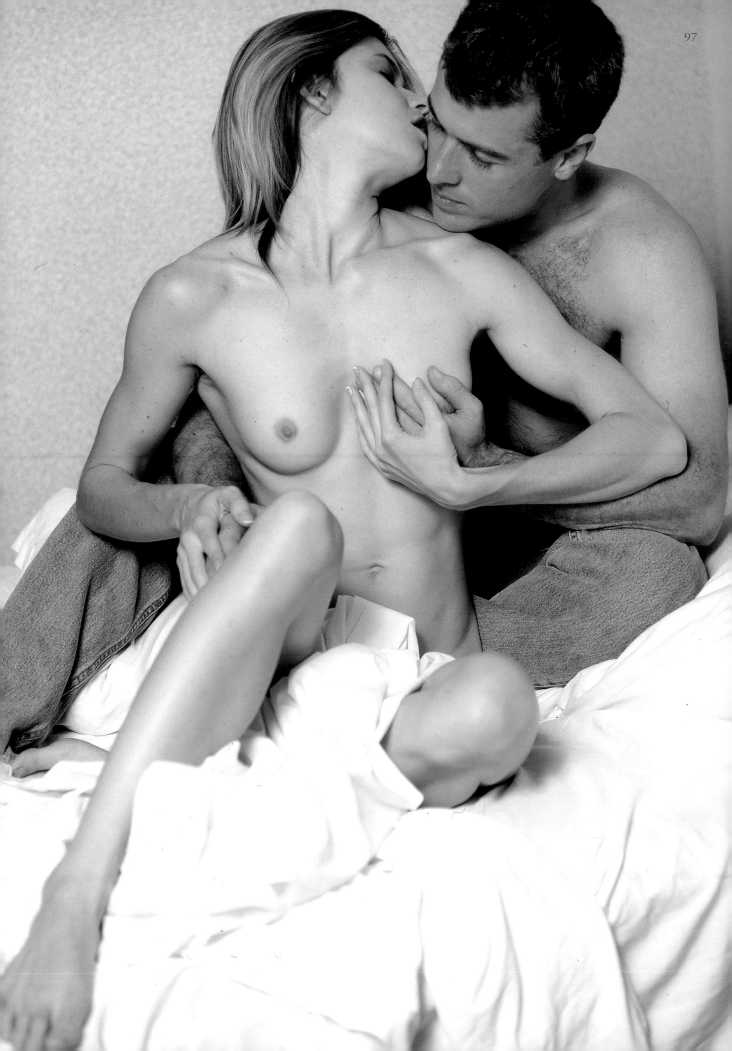

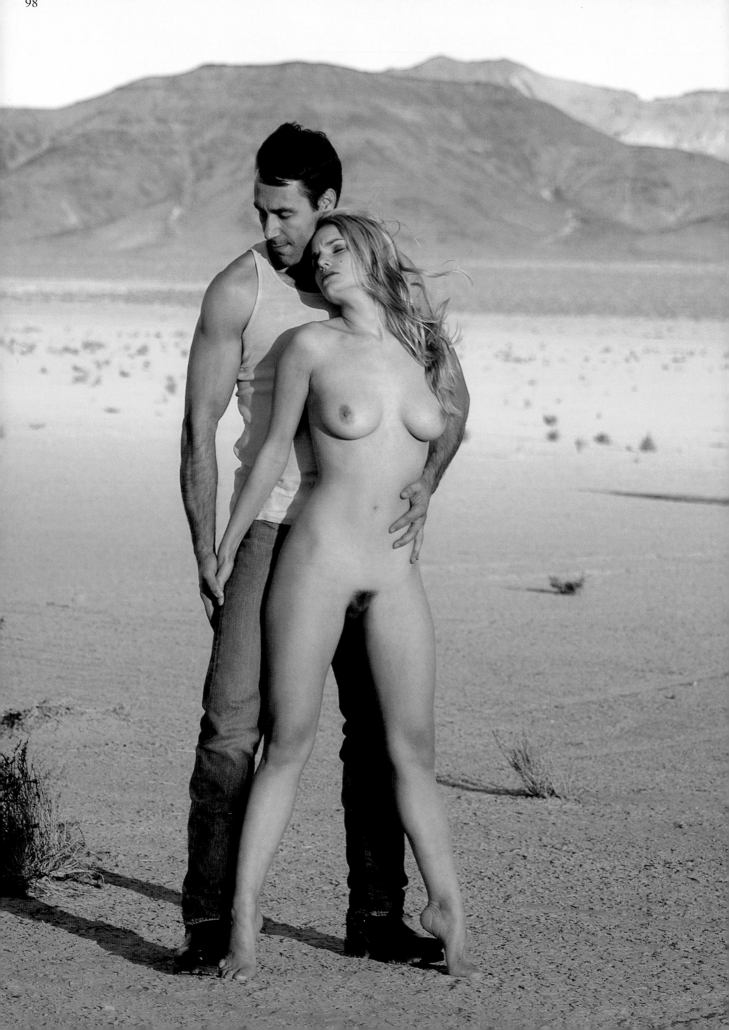

7. FINE ART AND BLACK & WHITE

Concluding this book is a selection of images classified as fine art. You'll notice that they stand apart from the others shown in the book. The sensuality they exude is less overt and is concerned more with shape, tone, light, and shadow than interesting locations or props. They are saturated in expression and emotion and spirit—some serious and some with a more contrived, animated, and exuberant feel. These portraits defy the standard portrait convention of simply "capturing the subject's likeness" and instead seem to capture the spirit. As such, these images give insight into each subject's personality.

◼ PROFILE

Lara, the model shown in image 100, was in her late teens when we created this portrait. Her mom and dad were present for the session, which was conducted in my studio.

Because of Lara's age, we decided to create a portrait that didn't show any frontal nudity. The pose was my idea. I love the triangular composition and the delicate position of her hands. In addition to ensuring modesty, the pose serves another goal: we are able to see more of her gorgeous, silky hair and her classically beautiful profile.

Lara is seated on studio gray seamless paper, which was also extended up the wall. Using the paper helped to create a continuous tone in the background and foreground of the image and eliminates even the slightest distraction from the subject.

A Nikon D1X and a 35–70mm Nikon lens were the tools of choice for creating this image. The lighting came from a 4x6-foot softbox positioned at camera right.

A profile head position is a pose that not all clients can pull off. To create this look, Lara turned her head until the left side of her face was fully out of view, keeping her eyes in line with her nose to achieve a natural, flattering look.

◼ CLASSIC BEAUTY

While the same props appear in image 101 that are used in several other images in this book, this portrait has a feel that's completely different than any other photograph shown in this book.

There's nothing like the flattering, diffuse, light produced by a softbox. Here, a softbox placed to camera left, along with a 42-inch white umbrella placed above the model's buttocks, produced a quality of light that's reminiscent of moonlight. Ariana is luminous, and her expression is serene.

Pulling all of her hair over to one side opened up her face, and her folded hands redirect the viewer's gaze upward. The limited depth of field in the image locks the viewer's gaze on the model's features, particularly her deep, dark eyes.

The image of Ariana was captured in color, then converted to black & white and toned using the Hue/Saturation method in Photoshop.

Be sure to network with your existing models in order to broaden your client base. I met Ariana when I was photographing her sister. I spoke to her about doing a session of her own and, luckily, she agreed. I created a number of striking images of Ariana during this session.

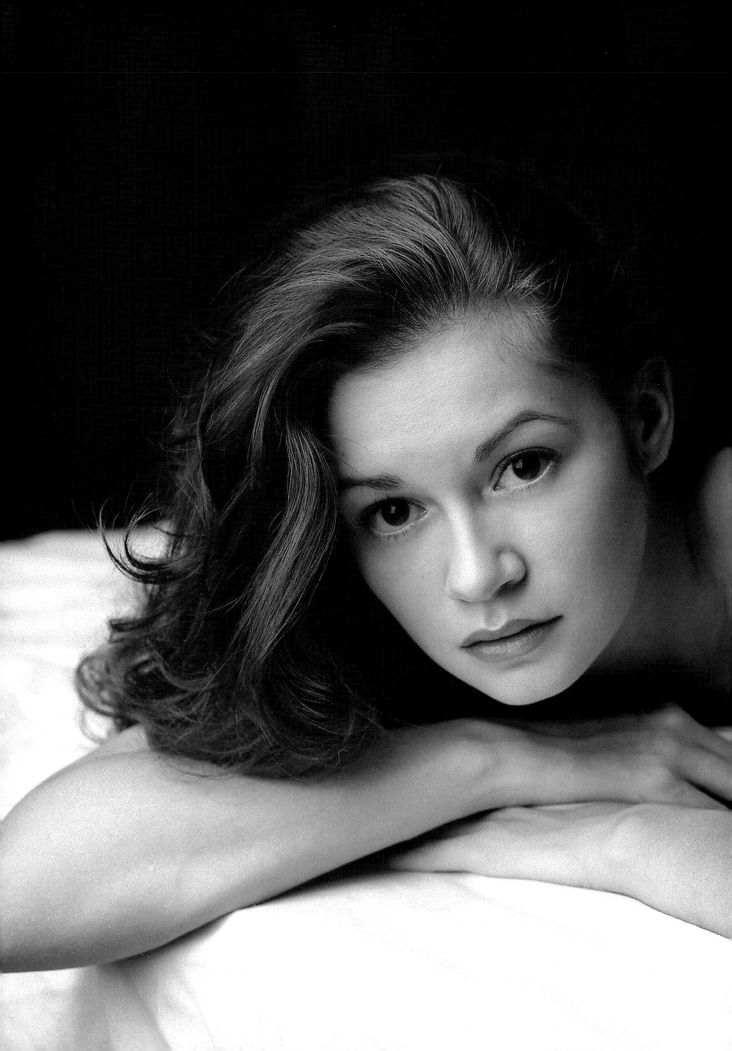

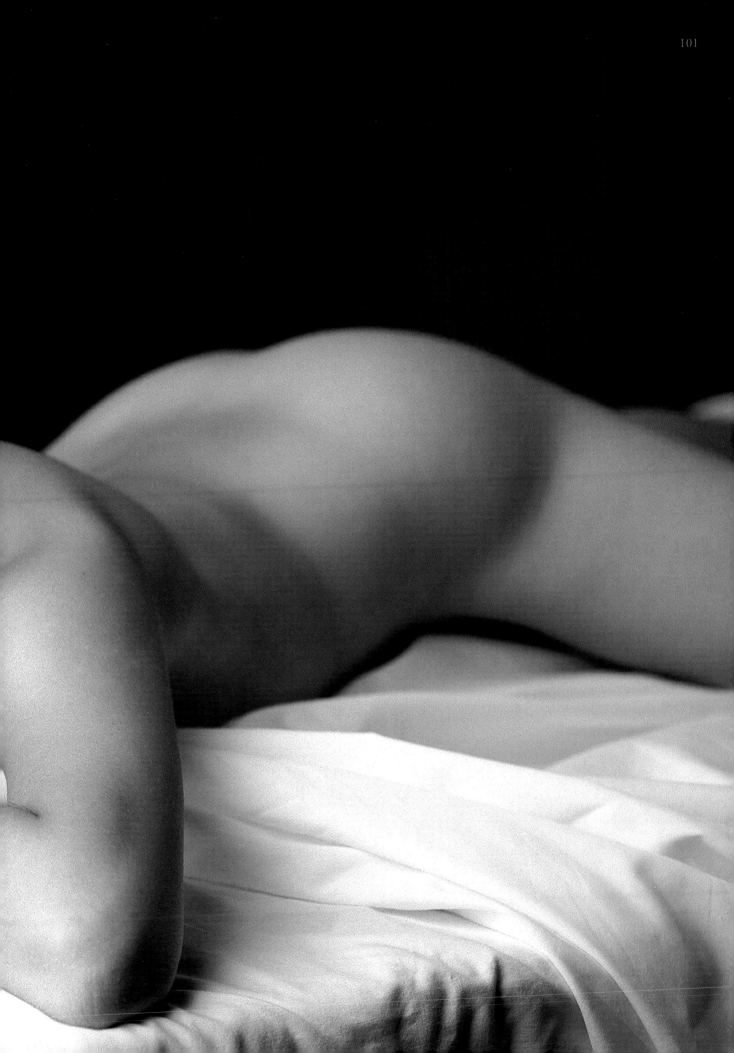

■ FIGURE STUDY

Images 102 and 103 were produced during a single session I conducted with Ashley. While the portraits were made a few years back, with my first digital camera, they have a reflective, highly artistic quality that I favor and still strive to produce in my sessions.

Here, the feel in the portraits is reminiscent of a figure study sketched in an artist's studio. The images have a highly personal, reflective quality that makes the viewer feel they are witnessing a private moment. The dramatic light and shadow patterns, created by a simple lighting setup that consisted only of a 4x6-foot softbox placed 90 degrees to camera left, are critically important to the effectiveness of these images.

It pays to do a long shot and a close-up with your model during the session. As you can see, each can create a dramatically different look.

Both portraits were created with a Canon Power-Shot G1 and were converted from color to black & white using the Hue/Saturation command in Adobe Photoshop.

■ PROOFING AND PRINTING

I proof the model's images immediately following the session using a slideshow presentation. While some photographers favor CD/DVD, on-line, or paper proofing, the slideshow option works best for me. I like that the images can be shown full-screen and we can easily cycle through the images, make notes, and go back to take a second look at the images.

I do all of my printing in-house, using an Epson 1280, a high-quality inkjet printer. For color images, I use Epson Premium Glossy Paper or Ilford Galerie Professional Photo Range Paper, a smooth, heavy-weight matte stock.

My black & white or toned images are typically printed on Legion Photo Matte paper.

■ PORTFOLIOS

Many models hire me to shoot images for their websites now, and digital portfolios have largely displaced paper ones.

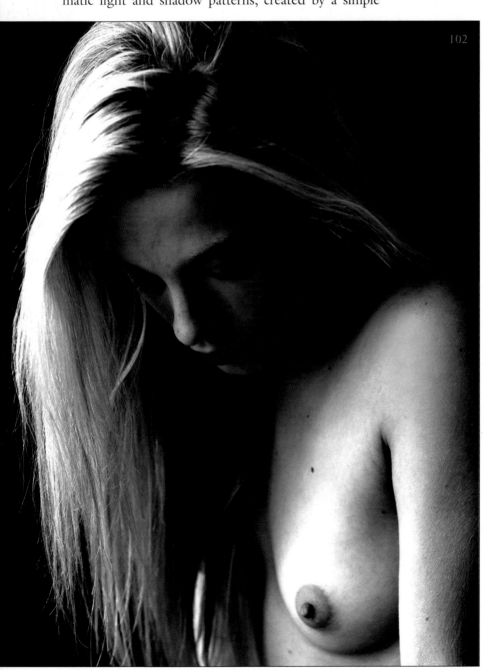

102

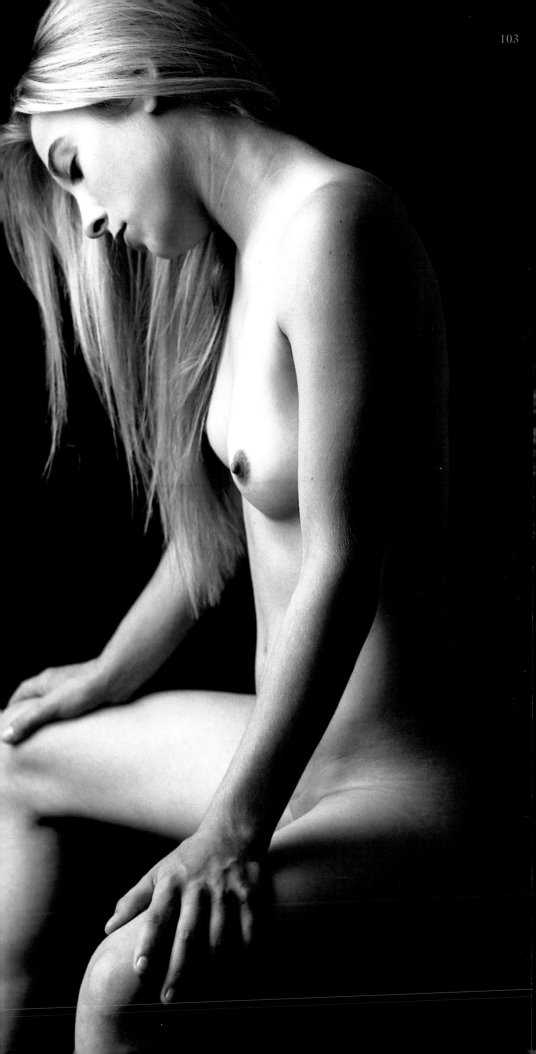

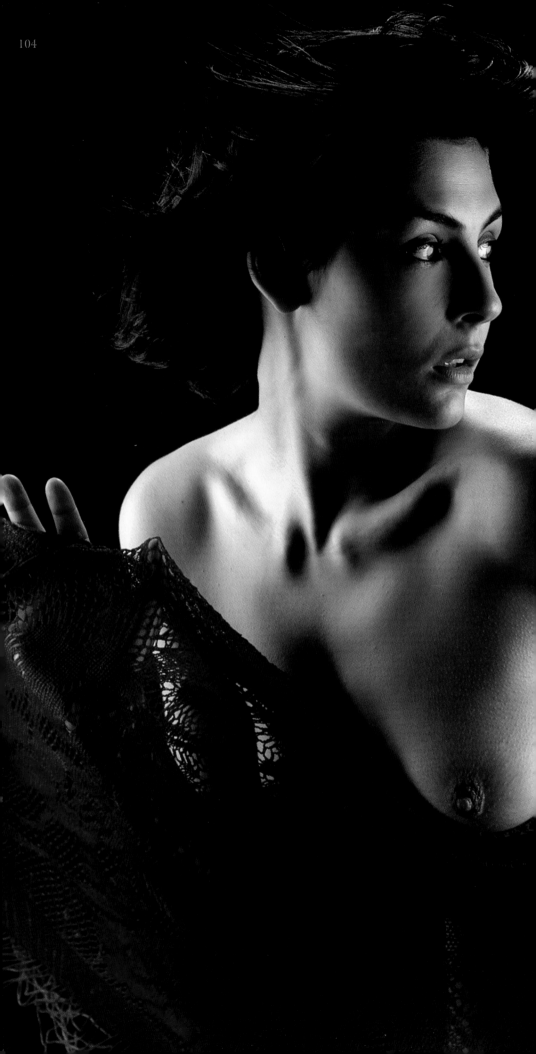

■ MOVEMENT

Models with dance training are very capable of using their body language to express themselves. Miriana is no exception to this rule, as is evidenced by the sense of drama in these distinctive images.

Images 104 and 105 were shot in Dallas, Texas with a Nikon D100 fitted with a 28–75mm Tamron lens.

I used two large, 4x6-foot softboxes—set 90 degrees to camera left and camera right—to create the lighting shown in image 104. A strobe head with a small silver umbrella served as a hairlight in order to create separation between the model's dark, wavy hair and the black velveteen backdrop.

Miriana developed this dramatic pose, and I caught her in action. The image was cropped in-camera.

The sheer white fabric purchased by my client was a welcome addition to this session with Miriana. For image 105, the model simply wrapped herself in the gossamer fabric and began to move dramatically in front of the camera. This pose is both feminine and evocative; it shows both grace and strength and is more expressive than most portraits.

Whether it's used in the background or as a prop, a swath of fabric can add texture and/or a burst of color to any image, with very little cost. Here, the sheer white cloth creates a billowing, fluid motion in the image and contrasts beautifully with the model's olive skin tones and the low-key black velveteen fabric that extends up the back wall and across the floor.

Miriana was lit with a hairlight that provided separation, plus two softboxes placed 90 degrees to camera left and right, facing the model.

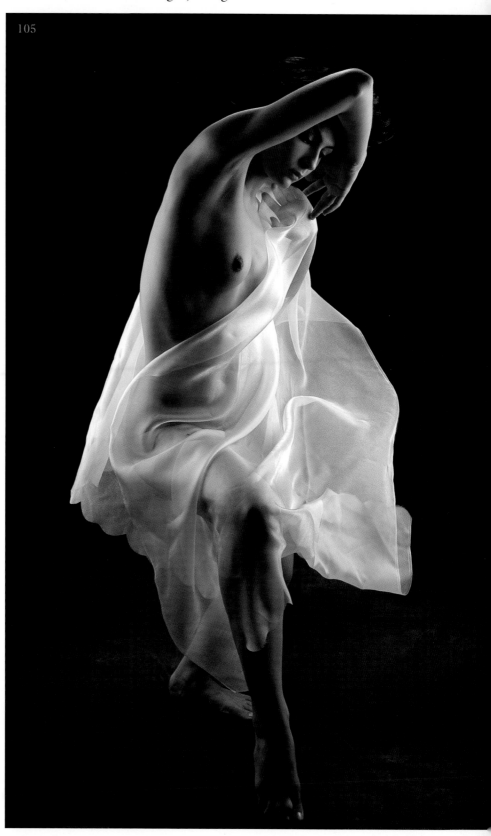

105

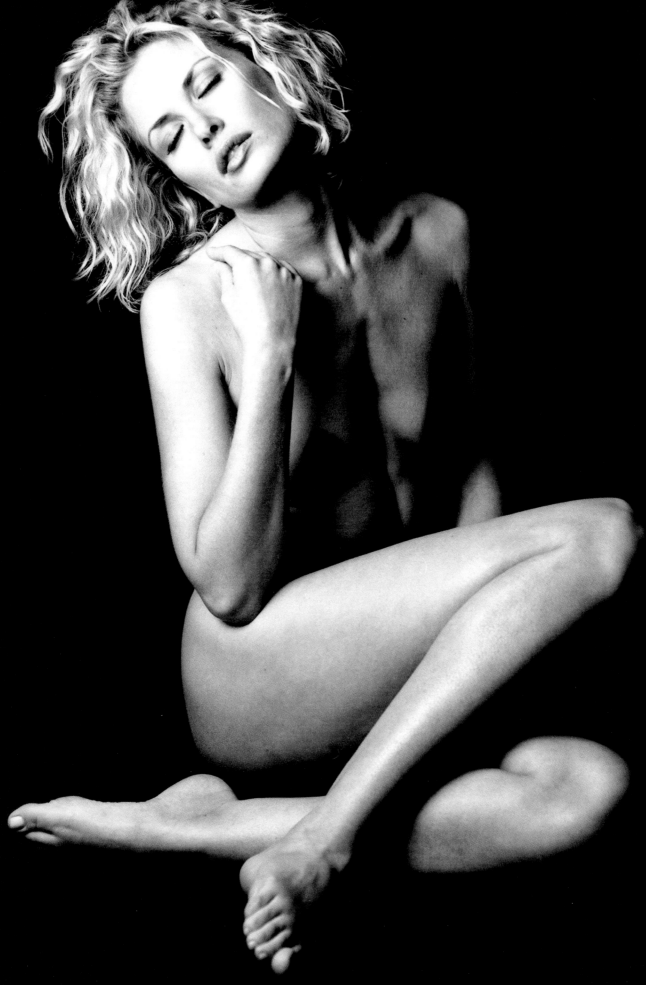

I've worked with Dayle, the model shown in image 106, for a great many years and have shot countless images of her. This one was made with a Canon Power-Shot G1 and a single 4x6-foot softbox, placed 45 degrees to camera left, which spilled a nice, diffuse quality of light across her form.

Dayle offered these kind words when I told her I was putting together yet another book:

> Bill and I met in 1989 at the beginning of our careers. We got so many great images that we could hardly choose the best ones. The magic continued in all of our shoots and kept getting better all of the time.
>
> Somewhere along the way, we became best friends. We've shared all of our stories from San Francisco to Europe. Our synergistic relationship has evolved into something unbelievable. When we shoot together, we know each other so well, words are hardly necessary. Bill tunes in to moods and style so quickly he's able to capture the perfect images.

Consider using testimony from your top models and contemporaries in your marketing to help further your reputation for your professionalism and artistry.

■ VARIATION ON A POSE

You'll instantly note the similarities in the poses used in images 106 and 107.

Sasha self-posed for image 107. Her torso is posed more square to the camera than is Dayle's, but the deep shadow across her form and the extreme angle of her raised leg shield a good portion of her body, though she is indeed fully nude. Using this strategy is a great way to ensure highly sensual images when a model is not comfortable with the idea of creating a more overtly sexy image. It bears repeating that model comfort is a critical element in capturing high-quality portraits.

Sasha was lit with a single 4x6-foot softbox, set 30 degrees to camera left. The image was made on a Canon PowerShot G1.

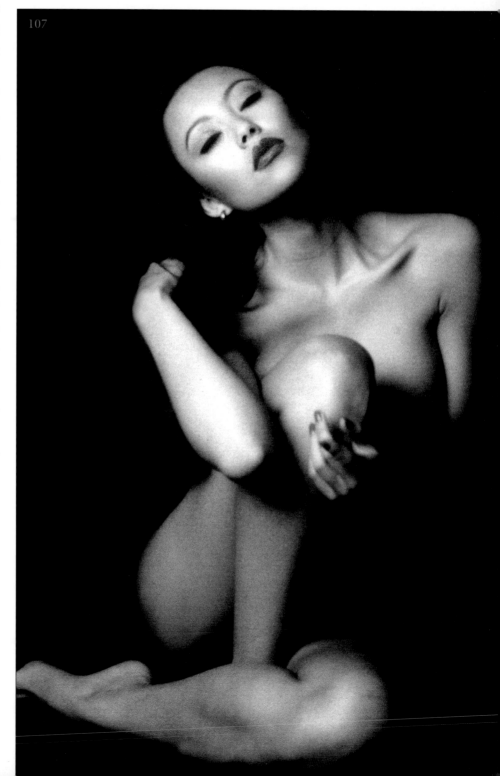

107

■ WINDOW LIGHT

Image 108 was created in the studio using only window light, which was solely responsible for the lovely highlights that appear in Liz's long, blond hair, the sensual shadowing of her features, and the form-flattering shadow that rims and enhances the shape and fullness of the model's left breast. There's a hint of mystery in the image; Liz seems to be peeking at the viewer.

I like Liz's position in the frame; the creative cropping is reminiscent of advertising or fashion photography, and it works beautifully here as well. I love the serious expression on Liz's face, and feel that the tight cropping emphasizes the strength she shows in her face. The softness that her long, cascading hair lends to the image and a layer of texture in the image.

The image was self-posed.

■ A RECIPROCAL ASSISTANCE

Hiring an assistant will allow you to better focus on your art and will further their skills. My friend and assistant, Spencer Colquhoun, considers his assistantship a valuable experience. He says,

> Bill truly loves photography and loves to share his knowledge. He is always communicating with professional and amateur photographers via e-mail or phone. They come to him with questions on how to do something, or just for his critique on their work. With his help, my photography has improved greatly.

■ A LITTLE INGENUITY

Our final portrait, image 109, shows the impact you can achieve when you think outside the box.

We purchased landscaping dirt from a local nursery, got Justine all wet, and painted on the dirt to form the basis for this savage, sexy look.

Justine's defiant pose and saucy expression bring a lot of emotion to the image and illustrate her talents as a professional model. This is one of my favorite images.

This image was captured in color then toned in Photoshop. A color version would not have quite the same impact. The hand-painted, earth-toned backdrop would compete with the model and distract from the texture in Justine's mud-caked skin. The toned presentation simplifies the image to its core elements; the color is rendered simply as added texture, and the overall look supports the mood that I wanted to create in the image.

A single 4x6-foot softbox, positioned 60 degrees to camera left, was the light source used in the image.

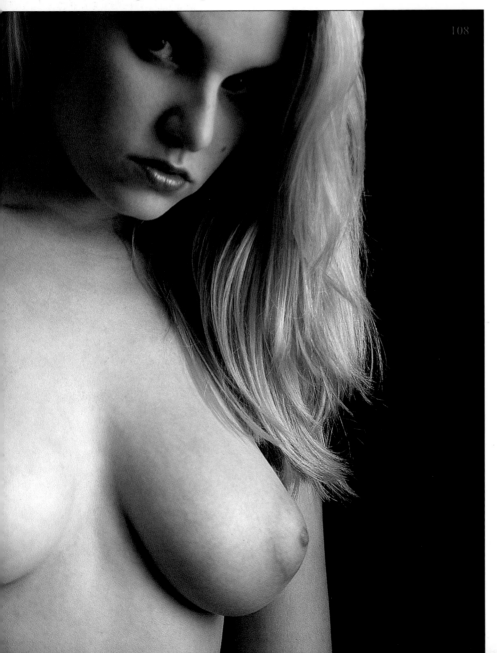

108

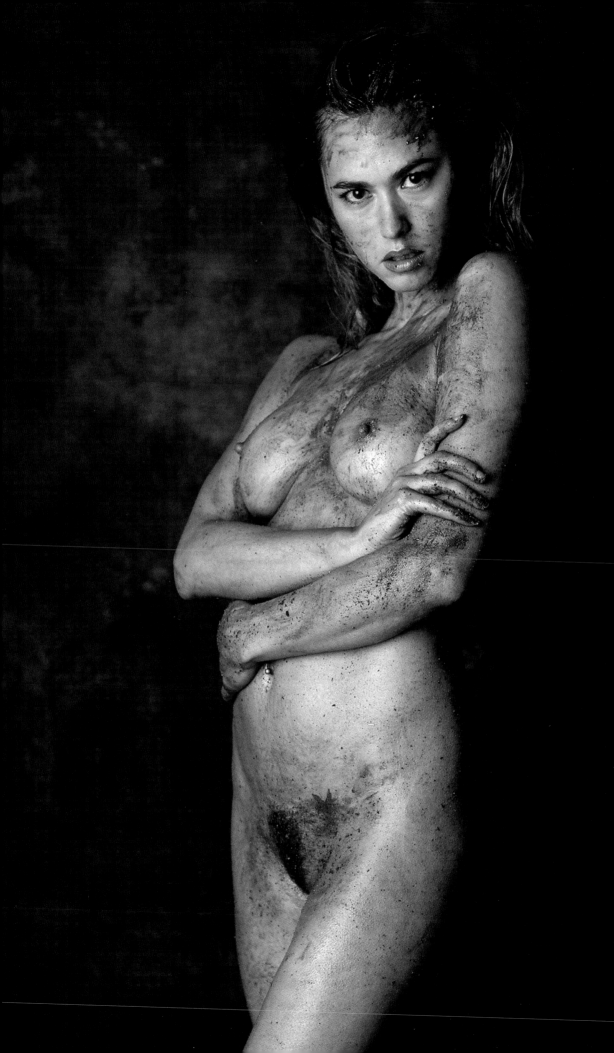

CONCLUSION

Photographers thrive on capturing beauty. With the ever-changing variables that photographing models presents—the different personalities, the myriad faces and forms, the changing locations—the task of photographing beautiful women is always challenging and entertaining. While there are certain constants in this line of work, each working day is different from the last, and each session is filled with unique rewards. The interaction with these girls and the satisfaction I get from creating great images are the two aspects of the job that please me most. It's been so much fun.

I hope that you're found in this book the techniques and artistic inspiration that you need to produce images that satisfy all of your artistic goals. Your first assignment? Find a beautiful subject, select a story-telling location that's suited to her look, and make an image that talks.

Best of luck!

ABOUT THE AUTHOR

Bill Lemon's photography career began in 1981, when he received a camera as a Christmas gift. As his enthusiasm grew, his friends helped him to purchase a little lighting equipment. He began to study instructional photography books and practiced his newly learned techniques, taking pictures of friends and family.

After two or three years of practice, Bill began to promote himself. He teamed up with some realtors, taking pictures of properties to be put on the market, then, in 1985, began to photograph models for an agency on weekends. It was this experience that taught him how models should be posed and made up for the camera.

Bill's real "break" came in 1986, with the publication of his first magazine cover, for *Studio Photography*. From there, things really took off. He opened his first studio in Novato, California, in 1989, and began shooting for Chevron, Mervyn's, Marin Apparel Company, and Alfa Vista, Inc. He moved his studio to a new Novato location in 1996 and picked up many new clients, including Bez Ambar, Inc., Promax, and Mollar Back Support (the ad has been running in *Sky Mall* for over a year now). In 2002, Bill entered the *American Photo* annual photo contest and won in the glamour division.

Over the years, Bill's portraits have appeared on fifteen magazine covers. He has authored three books and has just completed his first instructional DVD. He is active in the photographic community and leads workshops across the country.

For more information on Bill's work, visit his website at www.BillLemon.com.

Also by Bill Lemon . . .

BLACK & WHITE MODEL PHOTOGRAPHY

Create dramatic, sensual images of nude and lingerie models. Explore lighting, setting, equipment use, posing, and composition with the author's discussion of sixty unique images. $29.95 list, 8½x11, 128p, 60 b&w photos and illustrations, index, order no. 1577.

PROFESSIONAL SECRETS OF NUDE & BEAUTY PHOTOGRAPHY

Learn the technical aspects of composition and posing as well as how to ensure the comfort of your nude models. For photographers of all levels. $29.95 list, 8½x11, 128p, 60 b&w photos, order no. 1709.

OUTDOOR AND LOCATION PORTRAIT PHOTOGRAPHY, 2nd Ed.

Jeff Smith

Learn to work with natural light, select locations, and make clients look their best. Packed with step-by-step discussions and illustrations to help you shoot like a pro! $29.95 list, 8½x11, 128p, 80 color photos, index, order no. 1632.

POSING AND LIGHTING TECHNIQUES FOR STUDIO PHOTOGRAPHERS

J. J. Allen

Master the skills you need to create beautiful lighting for portraits. Posing techniques for flattering, classic images help turn every portrait into a work of art. $29.95 list, 8½x11, 120p, 125 color photos, order no. 1697.

DIGITAL INFRARED PHOTOGRAPHY

Patrick Rice

The dramatic look of infrared photography has long made it popular—but with digital it's actually *easy* too! Add digital IR to your repertoire with this comprehensive book. $29.95 list, 8½x11, 128p, 100 b&w and color photos, index, order no. 1792.

CORRECTIVE LIGHTING, POSING & RETOUCHING

FOR DIGITAL PORTRAIT PHOTOGRAPHERS, 2nd Ed.

Jeff Smith

Learn to make every client look his or her best by using lighting and posing to conceal real or imagined flaws—from baldness, to acne, to figure flaws. $34.95 list, 8½x11, 120p, 150 color photos, order no. 1711.

CLASSIC NUDE PHOTOGRAPHY

Peter Gowland and Alice Gowland

Gowland offers technical and practical advice from fifty years of experience. Fully illustrated, this book is a visual tribute to one of the most prolific and highly regarded photographers in the genre of nude photography. $29.95 list, 8½x11, 128p, 60 duotone photos, order no. 1710.

PORTRAIT PHOTOGRAPHER'S HANDBOOK, 2nd Ed.

Bill Hurter

Bill Hurter has compiled a step-by-step guide to portraiture that easily leads the reader through all phases of portrait photography. This book will be an asset to experienced photographers and beginners alike. $29.95 list, 8½x11, 128p, 175 color photos, order no. 1708.

TRADITIONAL PHOTO-GRAPHIC EFFECTS WITH ADOBE® PHOTOSHOP®, 2nd Ed.

Michelle Perkins and Paul Grant

Use Photoshop to enhance your photos with handcoloring, vignettes, soft focus, and much more. Step-by-step instructions are included for each technique for easy learning. $29.95 list, 8½x11, 128p, 150 color images, order no. 1721.

BEGINNER'S GUIDE TO ADOBE® PHOTOSHOP®, 2nd Ed.

Michelle Perkins

Learn to effectively make your images look their best, create original artwork, or add unique effects to any image. Topics are presented in short, easy-to-digest sections that will boost confidence and ensure outstanding images. $29.95 list, 8½x11, 128p, 300 color images, order no. 1732.

PROFESSIONAL TECHNIQUES FOR
DIGITAL WEDDING PHOTOGRAPHY, 2nd Ed.

Jeff Hawkins and Kathleen Hawkins

From selecting equipment, to marketing, to building a digital workflow, this book teaches how to make digital work for you. $29.95 list, 8½x11, 128p, 85 color images, order no. 1735.

PROFESSIONAL DIGITAL PHOTOGRAPHY

Dave Montizambert

From monitor calibration, to color balancing, to creating advanced artistic effects, this book provides those skilled in basic digital imaging with the techniques they need to take their photography to the next level. $29.95 list, 8½x11, 128p, 120 color photos, order no. 1739.

GROUP PORTRAIT PHOTOGRAPHY HANDBOOK,

2nd Ed.

Bill Hurter

Featuring over 100 stunning images by top photographers, this book offers practical techniques for composing, lighting, and posing group portraits—in the studio or on location. $34.95 list, 8½x11, 128p, 120 color photos, order no. 1740.

THE ART OF BLACK & WHITE PORTRAIT PHOTOGRAPHY

Oscar Lozoya

Learn how master photographer Oscar Lozoya uses unique sets and engaging poses to create black & white portraits that are infused with drama. Includes lighting strategies, special shooting techniques, posing strategies, and much more. $29.95 list, 8½x11, 128p, 100 duotone photos, order no. 1746.

THE BEST OF WEDDING PHOTOGRAPHY, 2nd Ed.

Bill Hurter

Learn how the top wedding photographers in the industry transform special moments into lasting romantic treasures with the posing, lighting, composition, album design, and customer service tips outlined in this must-have book. $34.95 list, 8½x11, 128p, 150 color photos, order no. 1747.

THE ART AND BUSINESS OF
HIGH SCHOOL SENIOR PORTRAIT PHOTOGRAPHY

Ellie Vayo

Learn the techniques that have made Ellie Vayo's studio one of the most profitable senior portrait businesses in the U.S. $29.95 list, 8½x11, 128p, 100 color photos, order no. 1743.

SUCCESS IN PORTRAIT PHOTOGRAPHY

Jeff Smith

Many photographers realize too late that camera skills alone do not ensure success in this competitive field. This book will teach photographers how to run savvy marketing campaigns, attract clients, and provide top-notch customer service. $29.95 list, 8½x11, 128p, 100 color photos, order no. 1748.

PROFESSIONAL DIGITAL PORTRAIT PHOTOGRAPHY

Jeff Smith

Because the learning curve is so steep, making the transition to digital can be frustrating. Author Jeff Smith shows readers how to shoot, edit, and even retouch their portraits—while avoiding common pitfalls—for better artistic expression and increased financial success. $29.95 list, 8½x11, 128p, 100 color photos, order no. 1750.

WEB SITE DESIGN FOR PROFESSIONAL PHOTOGRAPHERS

Paul Rose and Jean Holland-Rose

Learn how to design, maintain, and update your own photography web site—attracting new clients and boosting your sales. $29.95 list, 8½x11, 128p, 100 color images, index, order no. 1756.

PROFESSIONAL PHOTOGRAPHER'S GUIDE TO
SUCCESS IN PRINT COMPETITION

Patrick Rice

Learn from PPA and WPPI judges how you can improve your print presentations and increase your scores. $29.95 list, 8½x11, 128p, 100 color photos, index, order no. 1754.

THE BEST OF PORTRAIT PHOTOGRAPHY

Bill Hurter

View outstanding images from top professionals and learn how they create their masterful images. Includes techniques for classic and contemporary portraits. $29.95 list, 8½x11, 128p, 200 color photos, index, order no. 1760.

PHOTOGRAPHER'S GUIDE TO
THE DIGITAL PORTRAIT

START TO FINISH WITH ADOBE® PHOTOSHOP®

Al Audleman

Follow through step-by-step procedures to learn the process of digitally retouching a professional portrait. $29.95 list, 8½x11, 128p, 120 color images, index, order no. 1771.

THE PORTRAIT BOOK
A GUIDE FOR PHOTOGRAPHERS

Steven H. Begleiter

A comprehensive textbook for those getting started in professional portrait photography. Covers every aspect from designing an image to executing the shoot. $29.95 list, 8½x11, 128p, 130 color images, index, order no. 1767.

PROFESSIONAL STRATEGIES AND TECHNIQUES FOR DIGITAL PHOTOGRAPHERS

Bob Coates

Learn how professionals—from portrait artists to commercial specialists—enhance their images with digital techniques. $29.95 list, 8½x11, 128p, 130 color photos, index, order no. 1772.

LIGHTING TECHNIQUES FOR
LOW KEY PORTRAIT PHOTOGRAPHY

Norman Phillips

Learn to create the dark tones and dramatic lighting that typify this classic portrait style. $29.95 list, 8½x11, 128p, 100 color photos, index, order no. 1773.

THE BEST OF WEDDING PHOTOJOURNALISM

Bill Hurter

Learn how top professionals capture these fleeting moments of laughter, tears, and romance. Features images from over twenty renowned wedding photographers. $29.95 list, 8½x11, 128p, 150 color photos, index, order no. 1774.

THE DIGITAL DARKROOM GUIDE WITH ADOBE® PHOTOSHOP®

Maurice Hamilton

Bring the skills and control of the photographic darkroom to your desktop with this complete manual. $29.95 list, 8½x11, 128p, 140 color images, index, order no. 1775.

COLOR CORRECTION AND ENHANCEMENT WITH ADOBE® PHOTOSHOP®

Michelle Perkins

Master precision color correction and artistic color enhancement techniques for scanned and digital photos. $29.95 list, 8½x11, 128p, 300 color images, index, order no. 1776.

PORTRAIT PHOTOGRAPHY
THE ART OF SEEING LIGHT

Don Blair with Peter Skinner

Learn to harness the best light both in studio and on location, and get the secrets behind the magical portraiture captured by this award-winning, seasoned pro. $29.95 list, 8½x11, 128p, 100 color photos, index, order no. 1783.

PLUG-INS FOR ADOBE® PHOTOSHOP®
A GUIDE FOR PHOTOGRAPHERS

Jack and Sue Drafahl

Supercharge your creativity and mastery over your photography with Photoshop and the tools outlined in this book. $29.95 list, 8½x11, 128p, 175 color photos, index, order no. 1781.

POWER MARKETING FOR WEDDING AND PORTRAIT PHOTOGRAPHERS

Mitche Graf

Set your business apart and create clients for life with this comprehensive guide to achieving your professional goals. $29.95 list, 8½x11, 128p, 100 color images, index, order no. 1788.

MASTER POSING GUIDE FOR PORTRAIT PHOTOGRAPHERS

J. D. Wacker

Learn the techniques you need to pose single portrait subjects, couples, and groups for studio or location portraits. Includes techniques for photographing weddings, teams, children, special events, and much more. $29.95 list, 8½x11, 128p, 80 photos, order no. 1722.

BEGINNER'S GUIDE TO PHOTOGRAPHIC LIGHTING

Don Marr

Create high-impact photographs of any subject with Marr's simple techniques. From edgy and dynamic to subdued and natural, this book will show you how to get the myriad effects you're after. $29.95 list, 8½x11, 128p, 150 color photos, index, order no. 1785.

POSING FOR PORTRAIT PHOTOGRAPHY
A HEAD-TO-TOE GUIDE

Jeff Smith

Author Jeff Smith teaches surefire techniques for fine-tuning every aspect of the pose for the most flattering results. $29.95 list, 8½x11, 128p, 150 color photos, index, order no. 1786.

PROFESSIONAL MODEL PORTFOLIOS
A STEP-BY-STEP GUIDE FOR PHOTOGRAPHERS
Billy Pegram

Learn how to create dazzling portfolios that will get your clients noticed—and hired! $29.95 list, 8½x11, 128p, 100 color images, index, order no. 1789.

THE PORTRAIT PHOTOGRAPHER'S
GUIDE TO POSING
Bill Hurter

Posing can make or break an image. Now you can get the posing tips and techniques that have propelled the finest portrait photographers in the industry to the top. $29.95 list, 8½x11, 128p, 200 color photos, index, order no. 1779.

MASTER LIGHTING GUIDE
FOR PORTRAIT PHOTOGRAPHERS
Christopher Grey

Efficiently light executive and model portraits, high and low key images, and more. Master traditional lighting styles and use creative modi-fications that will maximize your results. $29.95 list, 8½x11, 128p, 300 color photos, index, order no. 1778.

INTO YOUR DIGITAL DARKROOM STEP BY STEP
Peter Cope

Make the most of every image—digital or film—with these techniques for photographers. Learn to enhance color, add special effects, and much more. $29.95 list, 8½x11, 128p, 300 color images, index, order no. 1794.

LIGHTING TECHNIQUES FOR
FASHION AND GLAMOUR PHOTOGRAPHY
Stephen A. Dantzig, PsyD.

In fashion and glamour photography, light is the key to producing images with impact. With these techniques, you'll be primed for success! $29.95 list, 8½x11, 128p, over 200 color images, index, order no. 1795.

PROFITABLE PORTRAITS
THE PHOTOGRAPHER'S GUIDE TO CREATING PORTRAITS THAT SELL
Jeff Smith

Learn how to design images that are precisely tailored to your clients' tastes—portraits that will practically sell themselves! $29.95 list, 8½x11, 128p, 100 color images, index, order no. 1797.

THE ART OF COLOR INFRARED PHOTOGRAPHY
Steven H. Begleiter

Color infrared photography will open the doors to a new and exciting photographic world. This book shows readers how to previsualize the scene and get the results they want. $29.95 list, 8½x11, 128p, 80 color photos, order no. 1728.

CREATIVE TECHNIQUES FOR COLOR PHOTOGRAPHY
Bobbi Lane

Learn how to render color precisely, whether you are shooting digitally or on film. Also includes creative techniques for cross processing, color infrared, and more. $29.95 list, 8½x11, 128p, 250 color photos, index, order no. 1764.

BIG BUCKS SELLING YOUR PHOTOGRAPHY, 3rd Ed.
Cliff Hollenbeck

Build a new business or revitalize an existing one with the comprehensive tips in this popular book. Includes twenty forms you can use for invoicing clients, collections, follow-ups, and more. $17.95 list, 8½x11, 144p, resources, business forms, order no. 1177.

PROFESSIONAL TECHNIQUES FOR
BLACK & WHITE DIGITAL PHOTOGRAPHY
Patrick Rice

Digital makes it easier than ever to create black & white images. With these techniques, you'll learn to achieve dazzling results! $29.95 list, 8½x11, 128p, 100 color photos, index, order no. 1798.

ARTISTIC TECHNIQUES WITH ADOBE® PHOTOSHOP® AND COREL® PAINTER®
Deborah Lynn Ferro

Flex your creative skills and learn how to transform photographs into fine-art masterpieces. Step-by-step techniques make it easy! $34.95 list, 8½x11, 128p, 200 color images, index, order no. 1806.

DIGITAL PORTRAIT PHOTOGRAPHY OF
TEENS AND SENIORS
Patrick Rice

Learn the techniques top professionals use to shoot and sell portraits of teens and high-school seniors! Includes tips for every phase of the digital process. $34.95 list, 8½x11, 128p, 200 color photos, index, order no. 1803.

THE BEST OF FAMILY PORTRAIT PHOTOGRAPHY

Bill Hurter

Acclaimed photographers reveal the secrets behind their most successful family portraits. Packed with award-winning images and helpful techniques. $34.95 list, 8½x11, 128p, 150 color photos, index, order no. 1812.

BLACK & WHITE PHOTOGRAPHY

TECHNIQUES WITH ADOBE® PHOTOSHOP®

Maurice Hamilton

Become a master of the black & white digital darkroom! Covers all the skills required to perfect your black & white images and produce dazzling fine-art prints. $34.95 list, 8½x11, 128p, 150 color/b&w images, index, order no. 1813.

NIGHT AND LOW-LIGHT

TECHNIQUES FOR DIGITAL PHOTOGRAPHY

Peter Cope

With even simple point-and-shoot digital cameras, you can create dazzling nighttime photos. Get started quickly with this step-by-step guide. $34.95 list, 8½x11, 128p, 100 color photos, index, order no. 1814.

MASTER COMPOSITION

GUIDE FOR DIGITAL PHOTOGRAPHERS

Ernst Wildi

Composition can truly make or break an image. Master photographer Ernst Wildi shows you how to analyze your scene or subject and produce the best-possible image. $34.95 list, 8½x11, 128p, 150 color photos, index, order no. 1817.

THE BEST OF PHOTOGRAPHIC LIGHTING

Bill Hurter

Top professionals reveal the secrets behind their successful strategies for studio, location, and outdoor lighting. Packed with tips for portraits, still lifes, and more. $34.95 list, 8½x11, 128p, 150 color photos, index, order no. 1808.

MARKETING & SELLING TECHNIQUES

FOR DIGITAL PORTRAIT PHOTOGRAPHERS

Kathleen Hawkins

Great portraits aren't enough to ensure the success of your business! Learn how to attract clients and boost your sales. $34.95 list, 8½x11, 128p, 150 color photos, index, order no. 1804.

LIGHTING AND EXPOSURE TECHNIQUES FOR

OUTDOOR AND LOCATION PORTRAIT PHOTOGRAPHY

J. J. Allen

Meet the challenges of changing light and complex settings with techniques that help you achieve great images every time. $29.95 list, 8½x11, 128p, 150 color photos, order no. 1741.

THE BEST OF TEEN AND SENIOR PORTRAIT PHOTOGRAPHY

Bill Hurter

Learn how top professionals create stunning images that capture the personality of their teen and senior subjects. $29.95 list, 8½x11, 128p, 150 color photos, index, order no. 1766.

DIGITAL PHOTOGRAPHY BOOT CAMP

Kevin Kubota

Kevin Kubota's popular workshop is now a book! A down-and-dirty, step-by-step course in building a professional photography workflow and creating digital images that sell! $34.95 list, 8½x11, 128p, 250 color images, index, order no. 1809.